Items should be returned on or before the last date shown below. Items not already requested by other borrowers may be renewed in person, in writing or by telephone. To renew, please quote the number on the barcode label. To renew on line a PIN is required. This can be requested at your local library.
Renew online @ **www.dublincitypubliclibraries.ie**
Fines charged for overdue items will include postage incurred in recovery. Damage to or loss of items will be charged to the borrower.

Leabharlanna Poiblí Chathair Bhaile Átha Cliath
Dublin City Public Libraries

Dublin City
Baile Átha Cliath

Leabharlann Shráid Chaoimhín
Kevin Street Library
Tel: 01 222 8488

Date Due	Date Due	Date Due

D1330583

First published 2017

Amberley Publishing, The Hill, Stroud
Gloucestershire GL5 4EP

www.amberley-books.com

Copyright © Pat Dargan, 2017

British Library Cataloguing in Publication Data.
A catalogue record for this book is available from the British Library.

ISBN 978 1 4456 7773 6 (print)
ISBN 978 1 4456 7774 3 (ebook)

Map illustration by User Design, Illustration and Typesetting.

Origination by Amberley Publishing.
Printed in Great Britain.

Contents

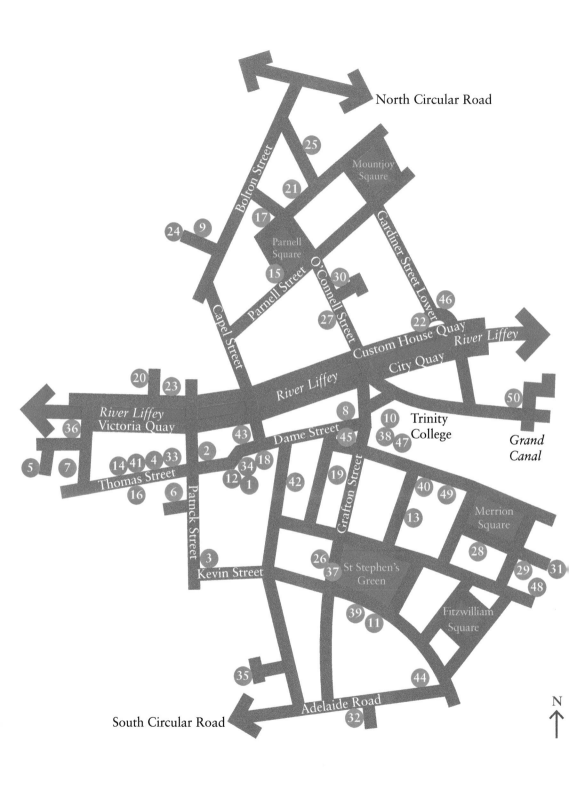

North Circular Road

25

Mountjoy Sqaure

21

Bolton Street

17

24 9

Parnell Square

15

Parnell Street

Capel Street

O'Connell Street

30

27

Gardiner Street Lower

46

22

Custom House Quay

River Liffey

20 23

River Liffey

City Quay

50

36

River Liffey
Victoria Quay

8

10 Trinity
College

Grand
Canal

43

Dame Street

45

38 47

5 7

2

34 18

19

40 49

14 41 4 33

12 1

42

Grafton Street

13

Merrion
Square

16 6

Patrick Street

28

29 31

3

Kevin Street

26

37 St Stephen's
Green

48

39 11

Fitzwilliam
Square

35

44

Adelaide Road

South Circular Road

32

N
↑

Key

1. Dublin Castle, Dame Street
2. Christ Church Cathedral, Christchurch Place
3. St Patrick's Cathedral, Patrick Street
4. St Audoen's Church, High Street
5. Royal Hospital, Military Road
6. Taylors' Hall, Back Lane
7. Former Dr Steevens's Hospital, Steevens's Lane
8. Parliament House (now Bank of Ireland), College Green
9. Carter's House, No. 9 Henrietta Street
10. Trinity College, College Green
11. Newman House, St Stephen's Green
12. Upper Castle Yard, Dame Street
13. Leinster House, Kildare Street
14. St Patrick's Windmill, Thomas Street
15. Rotunda Hospital, Parnell Street
16. St Catherine's Church, Thomas Street
17. Hugh Lane Gallery (formerly Charlemont House), Parnell Square
18. City Hall, Cork Hill
19. Powerscourt House, South William Street
20. Bluecoat School, Blackhall Place
21. Belvedere House, Great Denmark Street
22. Custom House, Beresford Place
23. Four Courts, Inns Quay
24. King's Inns, Henrietta Street and Constitutional Hill
25. St George's Church, Hardwicke Place
26. Royal College of Surgeons in Ireland, St Stephen's Green
27. General Post Office, O'Connell Street
28. Royal Society of Antiquaries of Ireland, No. 63 Merrion Square
29. Georgian Museum, No. 29 Fitzwilliam Street
30. St Mary's Pro-Cathedral, Marlborough Street
31. St Stephen's Church, Mount Street Crescent
32. Nos 6 and 7 Harcourt Terrace
33. St Audoen's Church, High Street
34. Chapel Royal, Cork Hill
35. Nos 36 and 37 Heytesbury Street Terrace
36. Heuston Station, John's Road/ Victoria Quay
37. Gate Lodge, St Stephen's Green
38. Museum Building, Trinity College
39. Newman University Church, St Stephen's Green
40. Former Kildare Street Club, Kildare Street
41. St Augustine and St John's Church, Thomas Street
42. South City Markets, South Great George's Street
43. Sunlight Chambers, Parliament Street
44. Royal Victoria Eye and Ear Hospital, Adelaide Road
45. O'Neill's Pub, Suffolk Street
46. Busáras (Central Bus Station), Beresford Place
47. Berkeley Library, Trinity College
48. Former Bank of Ireland Headquarters, Baggot Street
49. Millennium Wing, National Gallery, Clare Street
50. Bord Gáis Energy Theatre, Grand Canal Quay

Introduction

The historical core of Dublin has an extensive range of buildings that date from the medieval period of the thirteenth century to today. This volume explores fifty of this core's most significant buildings that lie within the inner-city area and which, in the writer's opinion, the city can be proud of. These examples are presented in the chronological sequence in which they were completed, and reflect the historic development and iconography of the city. Many of the buildings are accessible to the public; however, where public access is not available due to security, commercial or other reasons, this is noted.

In terms of development, the historic core of Dublin emerged in a sequence of progressions: Viking, medieval, Georgian and Victorian periods. The origins of the city date from the ninth century when a Norse seaport was laid out on the south bank of the River Liffey, although little of Viking Dublin survives above ground except for the street pattern around Christ Church Cathedral. The second phase of the city's development took place in the thirteenth century under the influence of the Normans. The Viking layout was extended and the overall settlement was enclosed within a formidable town wall. Today, few buildings of the medieval period remain intact. It was not until the late seventeenth century that work began on the laying out of the extensive Georgian sector of Dublin that extended well beyond the medieval walls. During this period, most of the fabric of the earlier medieval buildings was removed and new uniform streets, boulevards, malls and garden squares, were laid out – all lined with tall, narrow brick-built houses, as well as impressive stone public buildings. In effect, Georgian Dublin was laid in place within the curve of the North Circular and South Circular Roads – a framework that today defines the city's historic core. Throughout the nineteenth century the form of the Georgian city remained by and large in place, although from around 1850 some individual Georgian buildings were replaced by romantic-styled Victorian buildings. This process of occasional replacement within the historic core was again repeated in the twentieth century, when individual structures of concrete, steel and glass were completed. Beyond the historic core, the city went through considerable expansion during the nineteenth and twentieth centuries, so that today the outer limit of Dublin city is marked by the line of the M50 orbital motorway.

The 50 Buildings

1. Dublin Castle, Dame Street

Dublin Castle, the oldest building in the city, dates from 1204 when King John ordered the construction of a treasury and a fortress, which was built by Henry of London, Archbishop of Dublin. The original layout of the castle was rectangular, with a massive circular tower in each of the four corners.

In 1560 the castle became the viceregal residence and during the following sixteenth and seventeenth centuries it underwent considerable modifications. During the eighteenth

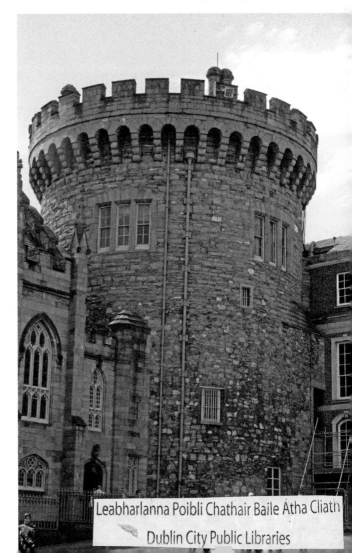

The circular Record Tower in Dublin Castle is largely intact, although topped with elaborate battlements that were added in the nineteenth century.

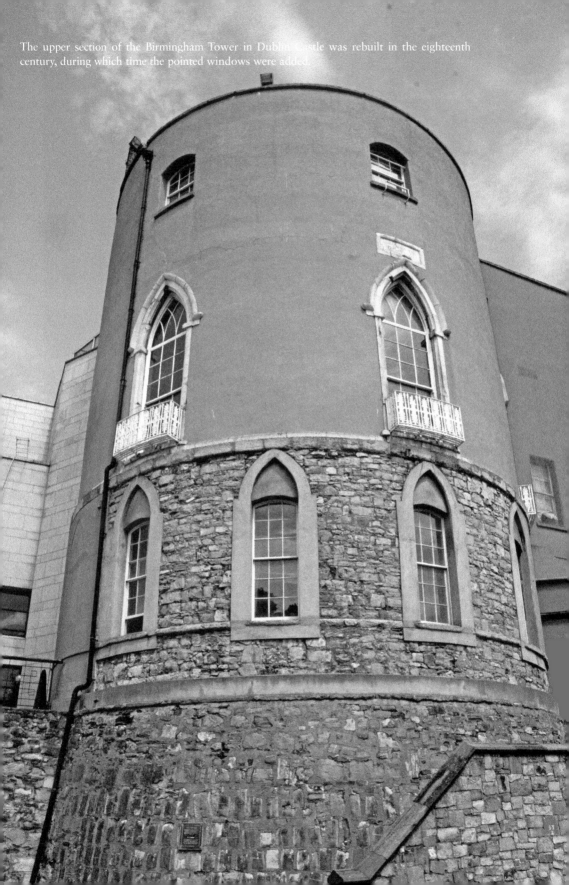

The upper section of the Birmingham Tower in Dublin Castle was rebuilt in the eighteenth century, during which time the pointed windows were added.

century the castle was even more extensively modified, to the extent that the bulk of the castle as it exists now dates from these eighteenth-century works.

Today only the two southern towers, the Birmingham and the Record towers, are all that survive of the original medieval structure. The Record Tower is the most in evident and lies between the east end of the State Apartments and the nineteenth-century Chapel Royal. The still massive stone drum is linked to both buildings and pierced with small irregularly placed windows. The tower was once used as a jail and suffered internal modifications during the nineteenth century, as well as the addition of elaborate battlements that cap the tower. The Birmingham Tower on the opposite end of the State Apartments block has been extensively modified. The base of the structure remains intact, but the upper levels were rebuilt in a Gothic Revival style during the late eighteenth century. The original circular form of the accommodation was retained and a number of tall pointed windows were inserted on two levels. Today the upper level of the drum has been rendered and coloured blue, below which the original masonry still manages to survive. Although small in scale the towers, when taken together, give an idea of the full extent of the Norman castle. An interesting feature adjacent to the Birmingham Tower is a short section of the medieval town wall that includes a postern, or small, gate.

2. Christ Church Cathedral, Christchurch Place

Christ Church Cathedral is the oldest of the city's medieval cathedrals and was established by King Sitriuc around 1030, although nothing remains of Sitriuc's building. In 1163, under the patronage of Archbishop Laurence O'Tool, the cathedral became an Augustinian priory. Following the arrival of the Normans, the cathedral went through several amendments and extensions, particularly in the period between the thirteenth and the fifteenth centuries. The priory was suppressed under the Reformation and the building was rendered into a secular cathedral. The monastic buildings were removed and, apart from the cathedral structure, all that survives is the stump of the chapter house in the cathedral grounds. The cathedral structure began to deteriorate over the following years and in 1868 the architect George Edmond Street was appointed to renovate the building. Street's work was extensive in the extreme, and amounted to an almost total rebuilding of the structure. It is therefore difficult to distinguish between the original Gothic elements and Street's nineteenth-century work, so that today the only areas of the twelfth-century structure that can be identified with certainty are the transepts, the tower and underground crypt that extends for the full length of the building. The nineteenth century also saw the construction of the connecting arch that dramatically spans Winetavern Street and provides access directly from the cathedral to the Synod Hall on the far side of the street.

Notwithstanding Street's work, the layout of Christ Church Cathedral consists of the nave, side aisles, transepts, choir and sanctuary, as well as the Peace Chapel, the Lady Chapel, St Edmund's Chapel and the Chapter House. In addition, it offers all the characteristic features of Irish Gothic architecture, including pointed door and window openings, leaded lights, flying buttresses, vaulted ceilings, steep gabled roofs, battlemented parapets, as well as a tall tower and spire. Underneath, the underground vault, with its heavy archways and vaulting, can be entered from the nave, and houses an extensive range of historical exhibits and a coffee shop.

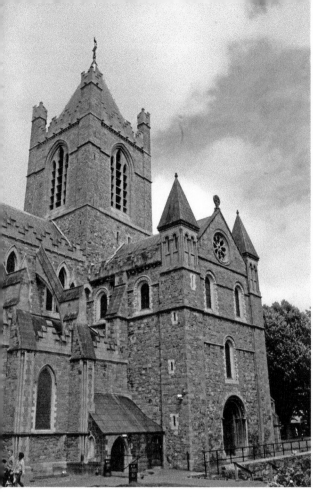

Left: The round-headed door and window openings as well as the tower of Christ Church Cathedral represent some of the oldest parts of the cathedral building.

Below: The Gothic features of Christ Church Cathedral, including the masonry, pointed arches, steep roof and tower, front onto Christ Church Place.

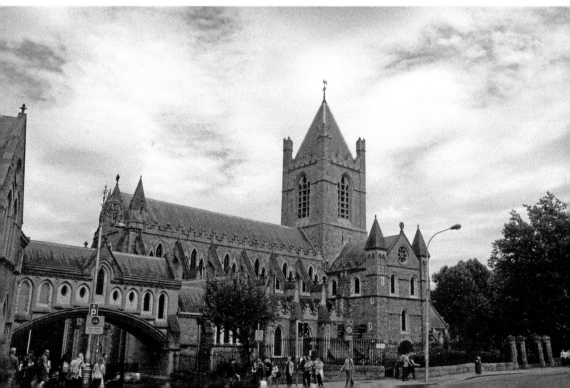

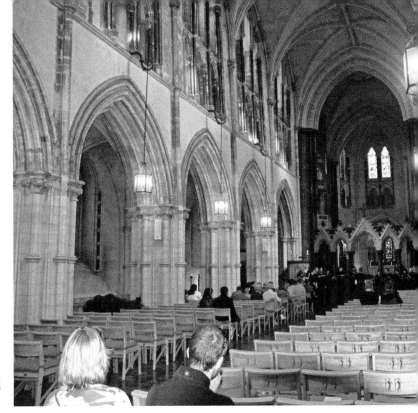

The nave of Christ
Church Cathedral
with its tall
arcade, high-level
walkways, Gothic
windows and ribbed
vaulted ceiling.

3. St Patrick's Cathedral, Patrick Street

The foundation of St Patrick's Cathedral dates from the Gaelic period around the tenth
century. The origins of the present building dates from the early part of the thirteenth
century and it was raised to cathedral status by Archbishop Henry of London around 1220.
Throughout the Middle Ages the cathedral was altered and extended, including the erection
of the north-west tower by Archbishop Minot in the early 1360s. During the Reformation
the cathedral was reduced to a parish church, but cathedral status was restored in 1555.
Following this, the condition of the structure began to deteriorate. Restoration work was
attempted, but progress was slow. In 1865, or thereabouts, Sir Benjamin Lee Guinness
agreed to finance the restoration on the condition that he alone and his builder, Murphy
Brothers, would be responsible for the restoration work. The result is that the present
Gothic appearance of the cathedral is due almost entirely to the Guinness restoration.

Externally the west front of the cathedral faces onto Patrick Street and has a decidedly
vertical emphases with its Gothic door and windows, buttresses and tower – the latter
with a clock face, battlements and a tall spire. Round the corner, the side walling follows
the Gothic arrangement with high gables, entrance porches, pointed windows and flying
buttresses that front onto St Patrick's Close, while the opposite elevation overlooks
St Patrick's Park. The interior of the cathedral is arranged in a cruciform plan with a nave,
side aisles, a side arranged choir and sanctuary, behind which is the Lady Chapel. The
interior of the cathedral has all the characteristics of the Gothic: pointed arched openings,
slender windows, stained-glass work, triple-level arcades, high-level walkways, soaring
shafts and ribbed vaulting. The interior also has a rich body of commemorative wall

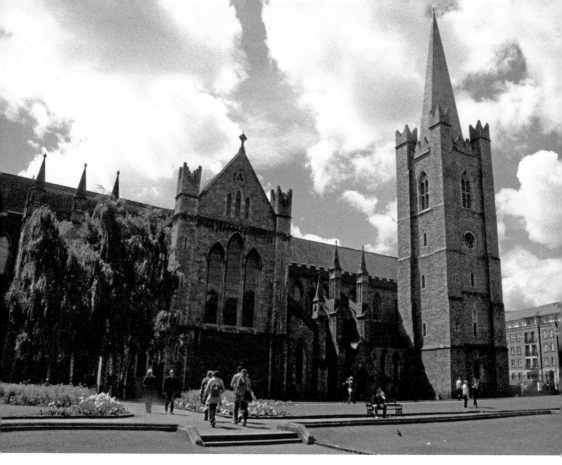

Above: The tower and north side of St Patrick's Cathedral face onto St Patrick's Park.

Left: The vertically emphasised front of St Patrick's Cathedral at the junction of Patrick Street and St Patrick's Close.

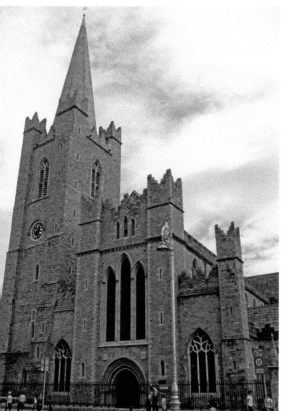

plaques and military standards and it was here that Jonathan Swift wrote *Gulliver's Travels* (1726), *A Modest Proposal* (1729) and *A Tale of a Tub* (1704), while he was dean of the cathedral in the eighteenth century.

4. St Audoen's, High Street

St Audoen's is the only one of the city's medieval churches to remain in parish use and although small in scale, the layout was completed in four stages. The initial nave was completed around 1200, to which an eastern chancel was added around 1300. One hundred and thirty years later St Anne's Chapel was added to the south side and the tower was added to the west end. In 1482 the church was extended eastwards by Baron Portlester to create the Portlester Chapel. During the nineteenth century, the church community was reduced and the roofs of both St Anne's and the Portlester Chapel were removed, although the original nave and the tower remained in use. Later the roof of St Anne's Chapel was restored and the space was fitted out as a visitor centre. A new contemporary-styled entrance porch was added that leads into the visitor centre, where a collection of material relating to the history of the church is displayed. A doorway from the here provides access to the nave. Here a range of tall north facing windows light the interior, while on the opposite wall the arcade that originally separated the nave from St Anne's Chapel remains, although bricked up. Elsewhere, the nave has a simple altar, a Gothic east window and a plain curved ceiling.

St Audoen's Church with its front garden, side entrance porch and tower.

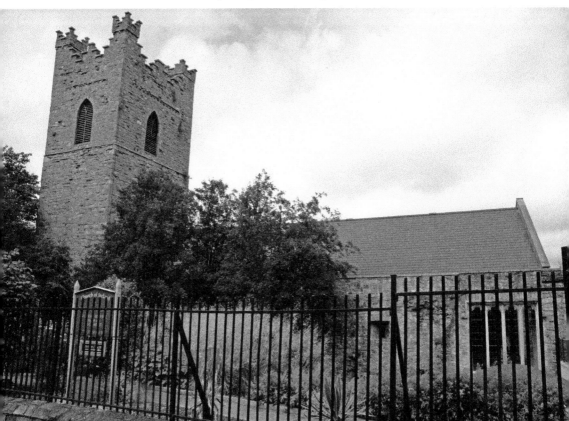

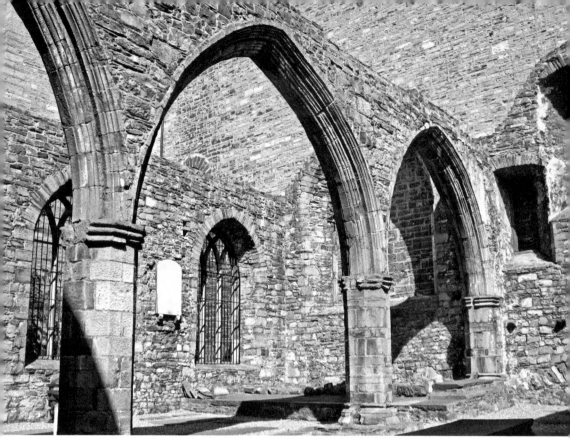

The surviving interior of the unroofed Portlester Chapel offers an attractive, hard landscaped church garden.

5. Royal Hospital, Military Road

The Royal Hospital, now the Museum of Modern Art, was the first Georgian-style building completed in Ireland and dates from 1680 when the Duke of Ormond set up a home for retired soldiers in Kilmainham. The building was designed by Sir William Robinson and was completed over a number of years.

The layout consists of a central courtyard, enclosed on four sides by an open arcade that provided entrances to the retired soldiers' quarters on the south, east and west sides, while the governor's quarters, dining hall and chapel fill the north side. The accommodation blocks are double storey in height with a slated dormer storey overhead. Externally each of the three floors is faced in grey rendering with Georgian-style up-and-down sliding sash window divided into small panes on each level. Each side has a projecting central bay with an arched opening at ground level that provided access to the inner courtyard and has a triangular pediment at roof level. The inner courtyard elevation is different. Here the open arcade has square columns and semicircular arches, with vertical sash windows on the upper- and dormer-floor levels. The double-storey north block has a projecting bay with a central arched doorcase flanked by full height round-headed windows, on either side of which the chapel and Governor's Quarters have similar but narrower windows. Over the projecting bay of the central block is a tall clock tower with a spire.

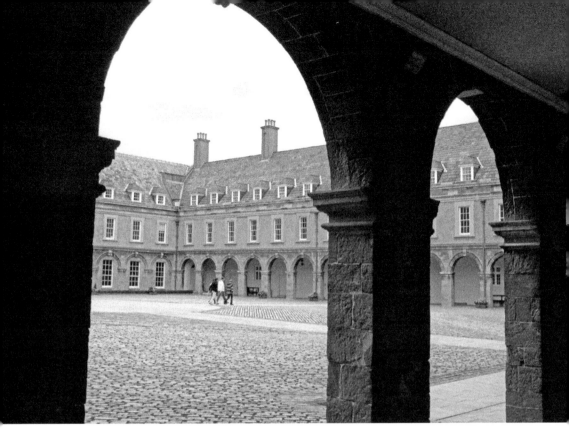

Above: Central courtyard of the Royal Hospital with the arched open arcade and two upper floors.

Below: Projecting entrance bay of the Royal Hospital with the arched access to the internal courtyard, characteristic Georgian sash windows and triangle pediment at roof level.

Left: Open arcade of the Royal Hospital with semicircular arches providing access to the ground-level quarters.

Below: Royal Hospital north block with a triangular pediment and round-headed windows.

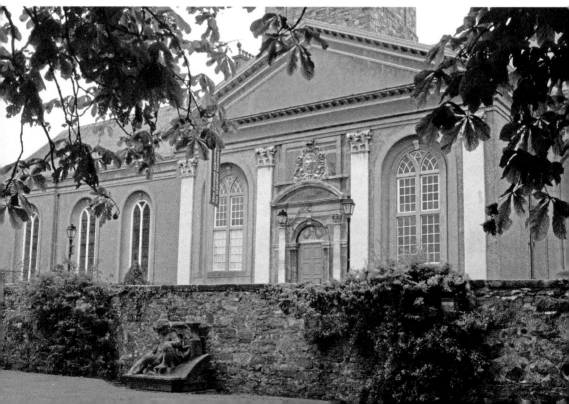

6. Taylors' Hall, Back Lane, 1703

Taylors' Hall is the only surviving guildhall in Dublin and is sandwiched between Back Lane and High Street. The building dates from around 1703 and the architect seems to have been Richard Mills, which suggests it is one of the earliest brick-faced Georgian houses in Dublin. Over its lifetime it acted as a church, college and now acts as the headquarters of An Taisce: The National Trust for Ireland. The treatment of the elevation is unusually complex: double storey on one side and single storey on the other. In addition, one side of the entrance doorway is longer than the other. The basement is stone built, above which there are two storeys of brick and a high-pitched attic behind a brick parapet. The entrance doorway at ground level is reached by an elaborate stone stairway. The doorcase itself is framed with a stone surround and is capped with a small triangular pediment. To the left of the door, four tall round-headed sash windows provide light to the assembly hall behind, while on the opposite side the double-storey section has vertically proportioned sash windows on two levels. The elevation onto High Street, at the rear of the building, is simpler with a pair of round-headed windows flanking a chimney gable. Internally the building has an elegant double-height assembly hall and a notable stairs. The building is in office use, although it is accessible to the public at times.

The asymmetrical elevation of Taylors' Hall has double-height round-headed sash windows on one side and more conventional rectangular Georgian sash windows on the other.

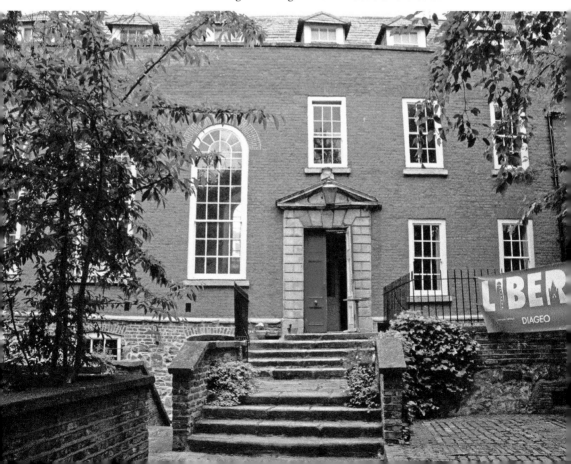

7. Former Dr Steevens's Hospital, Steevens's Lane

When Dr Richard Steevens died in 1710 he left his estate to his sister Grizel for the duration of her life, after which the estate was to go to setting up a hospital for the sick of Dublin. Grizel outlived her brother by thirty-seven years. Nevertheless, she set about establishing a board to build the hospital and nine years later and the hospital opened for patients in 1733.

Thomas Burgh was appointed architect for the project, although he charged no fee for his services. Burgh drew heavily on the layout of the Royal Hospital for his design, which consisted of a double-storey courtyard plan with an attic storey in the slated roofs.

The original entrance faced onto Steevens's Lane, and consists of a wide block with a central bay and a projecting bay at each extremity. The building is rendered with a stone dressing. The central bay has an entrance archway with a stone frame, and a triangular pediment at roof level. This archway leads into the quadrangle, where the four sides of the building are arranged around a central green. This has an arched stone arcade that extends around the quadrangle at ground level, and tall sash windows on the upper floor. A curious feature is projecting corner angles at roof level. These housed toilet accommodation that was added in 1865.

In 1732 the Edward Worth Library was established in the building and for a short time the hospital operated a medical school. In 1987 the hospital was closed and the building was converted to office use for the Health Board. At the same period the north front on St John's Road was reorganised and a new front, echoing the Steevens's Lane front, was added. At the same time a new landscaped garden was created, the entire north elevation now acting as the main entrance to the building. The hospital is now in office use and access is not available.

The original entrance front to Dr Steevens's Hospital on Steevens's Lane.

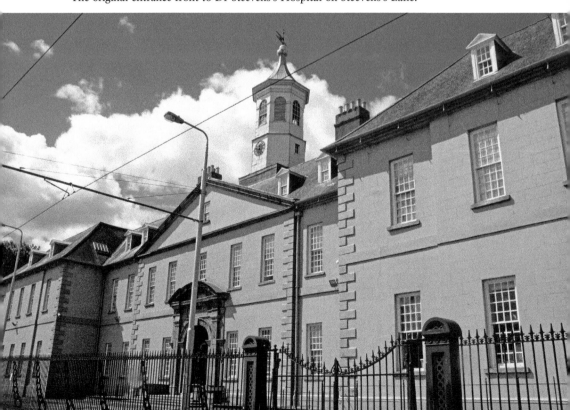

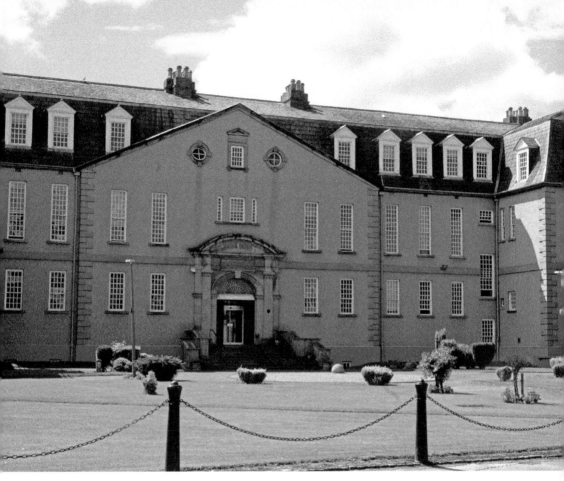

The 1987 north front of Dr Steevens's Hospital and front garden facing St John's Road.

8. Parliament House (now Bank of Ireland), College Green

Parliament House was designed for the Irish Parliament by Sir Edward Lovett Pearse and dates from 1729. The layout is complex and consists of a tall, open stone loggia of columns with three projecting porticos that open onto a railed forecourt. The wide central portico has four columns that support a triangular pediment with figure sculptures. At the ends of the block the two outer porticos project further out, each with a semicircular arch flanked on either side by single columns. In 1739 the original block was extended on both sides by the addition of a curved wing wall of alternating blank niches and columns, the east wing of which swung around the corner into Westmoreland Street. Later in 1785 the east wing was extended further when the entrance portico of Irish House of Lords was added by James Gandon. This consists of six columns and an overhead triangular pediment with figure sculptures. Despite the phased development, the overall frontage of Parliament House reads as a single composition. Following the dissolution of the Irish Parliament in 1800, the building was taken over by the Bank of Ireland and much of the interior of the building was extensively altered in the nineteenth century, and only the chamber of the Irish House of Lords survives intact.

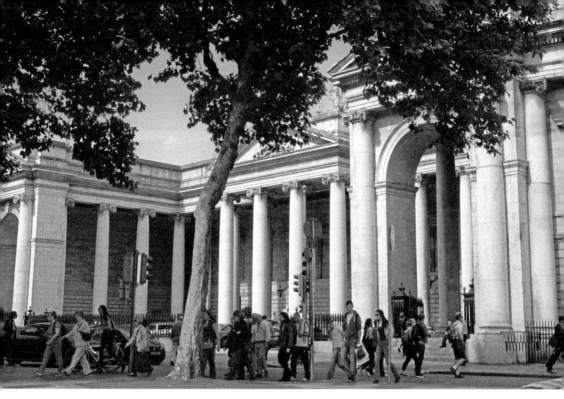

Above: The open loggia and porticos of Parliament House, which faces onto College Green.

Below: The curved wing walls of Parliament House with alternating niches and columns.

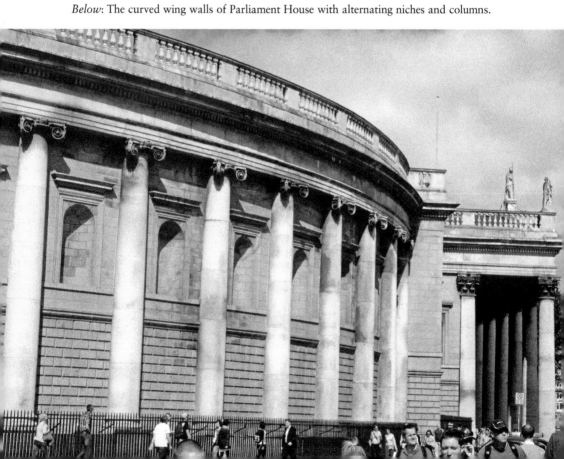

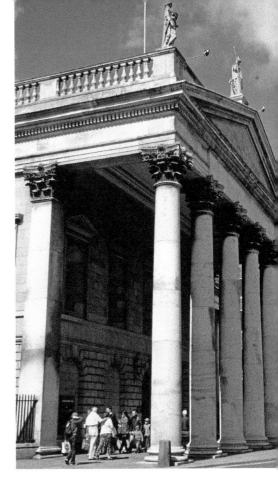

The Irish House of Lords portico opens onto Westmoreland Street.

9. Carter's House, No. 9 Henrietta Street

Henrietta Street was the first Georgian Street laid out in Dublin by Luke Gardiner and built in stages from 1729 onwards. No. 9 was built for Thomas Carter a year or so later and was probably designed by Sir Edward Lovett Pearce. The house stands three floors over a basement, with an attic storey in the roof and is one of the first domestic Georgian buildings completed in Dublin. The ground level is rendered and rusticated to imitate stone, above which the remainder of the elevation is brick. At roof level the house has a stone parapet that partially hides the square dormer windows. The elevation of the block is symmetrical, or Palladian, a common arrangement of many of the large Dublin Georgian mansions.

No. 9 features a central doorcase at ground level with a round-headed sash window on the first floor immediately above. Elsewhere the remainder of the windows are standard vertically proportioned Georgian sash windows, each one subdivided into small panes. The doorcase has a stone surround with a pronounced keystone and an overhead triangular pediment. Access to the doorway is provided by a short bridge that spans over the basement area, with the bridge and the rest of the basement area protected by a metal railing. Overhead, the first-floor window is flanked by shallow projecting columns, the line of which is carried over the round-headed window. Today the house is in use as a convent and is not accessible to the public.

Above: Carter's House, with its symmetrical Palladian elevation of brick and rendering, one of the first Georgian houses to be built in Henrietta Street.

Left: The central bay of Carter's House has the entrance doorcase and first-floor round-headed sash window symmetrically placed.

10. Trinity College, College Green

Trinity College was established by Queen Elizabeth in 1592, although nothing survives of the structures from that period. Today the college is laid out in a sequence of interconnected quadrangles enclosed by buildings from various periods of the college's history. Collectively the Georgian buildings of Trinity College make up the largest collection of eighteenth-century buildings on a single site in Ireland. The Trinity site was originally a twelfth-century Augustinian priory that was granted to the City Corporation at the Dissolution. The site then acted a hospital until it was granted to the college authorities in 1592. Historically the college has produced many internationally notable graduates, including Oscar Wilde, Samuel Beckett, Jonathan Swift, Bram Stoker, Edmond Burke, James Ussher, George Berkeley, Oliver Goldsmith and R. F. Foster.

Today the Georgian buildings of Trinity College are grouped mainly around two quadrangles – Parliament Square and Library Square – and include the Rubrics (1700), the Old Library (1712), the Printing House (1734), the West Front (1752), the Provost's House (1759) the Dining Hall (1760), the Examination Hall (1777) and the Chapel (1787). The Old Library that was designed by the architect Thomas Burgh is a remarkably long structure – over 60 metres in length – and stands three storeys high. Originally the ground level had an arched arcade but this was later filled in, although the arched openings survive as windows. The library, which houses and displays the Book of Kells, is open to the public.

The wide four-storey West Front of the college was designed by Theodore Jacobsen; it closes the east end of Dame Street and incorporates the tall entrance arch to the

The Old Library is one of the oldest buildings in Trinity College, where the Book of Kells is on display.

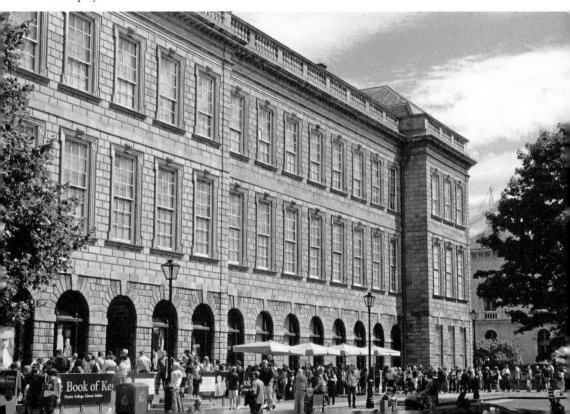

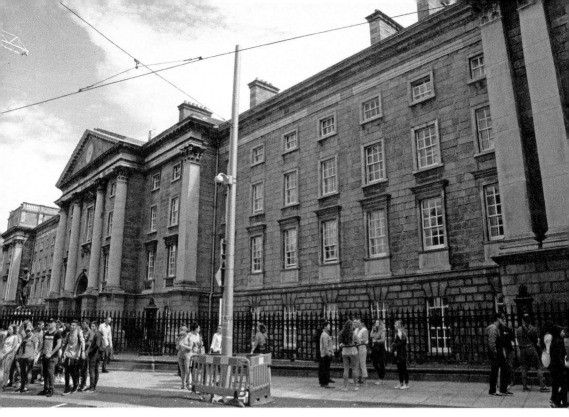

Above: The extensive west front of Trinity College closes the eastern end of College Green and backs onto Parliament Square within the college grounds.

Below: The Trinity College Examination Hall and part of the south wing of the west front that faces onto Parliament Square.

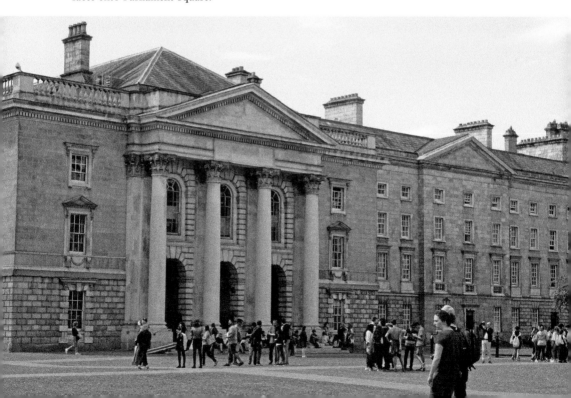

college grounds. Inside the college the front and its two perpendicular side wings enclose Parliament Square, at either end of which is the chapel and examination hall respectively – both were planned but not built by Sir William Chambers. Visitors are encouraged to visit the college grounds, but as most of the buildings are in educational use student and staff access only is permitted.

11. Newman House, St Stephen's Green

Newman House is actually a pair of houses – Nos 85 and 86 – built at different times. The architect for No. 85 was Richard Castle and the house was built for Hugh Montgomery in 1738. The building was purchased by Richard Whaley, who extended the accommodation by building No. 86 on the adjoining site to the design of Robert West in 1765. In 1854 Cardinal John Henry Newman established the Catholic University of Ireland here, which went on to developed into University College Dublin, where early students such as Gerard Manley Hopkins and James Joyce attended.

The combined elevation of Newman House blends into the terraced brick blocks on the east side of St Stephen's Green and face the landscaping of the green on the far side of the road. No. 85, the smaller of the two stone buildings, is Palladian in style with two storeys over the basement. The ground-level stonework is rusticated so the joints are accentuated, while the upper level has ashlar, or fine joints. The central entrance door is arched with a semicircular fanlight, while the upper level has a central three-part Venetian window, above which the roof line is highlighted by balusters.

The three- and four-storey stone elevations of Newman House blend into the Georgian streetscape of St Stephen's Green.

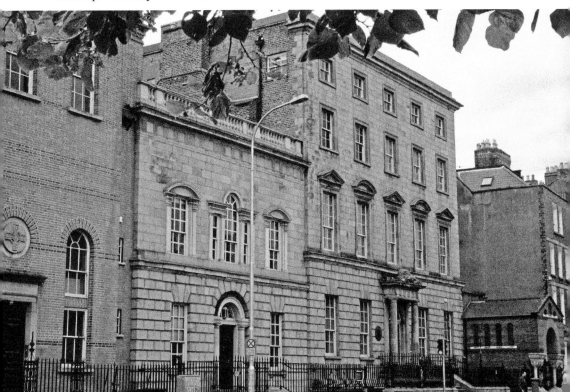

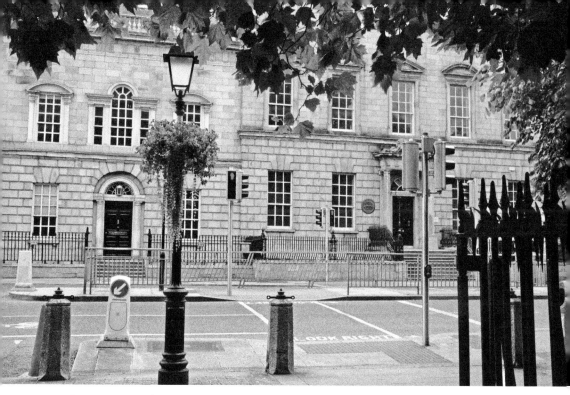

Newman House faces across the street and into the landscaped green.

No. 86 is a much larger building. It is four storeys high and has five sash windows across the front and a central doorcase at ground level. Each of the houses has an open area at basement level, with stone steps to the doorway and protective metal railings. The houses were restored 1989 and both have spectacular plasterwork and internal joinery. They remain part of University College Dublin and are open to visitors at certain times.

12. Upper Castle Yard, Dame Street

Established in 1204, Dublin Castle went through extensive alterations, particularly between the fifteenth and seventeenth centuries. The eighteenth century saw later developments when most of the early structures were removed and replaced by a range of Georgian building. During the same period the castle remained in use as the centre of imperial rule in Ireland until 1922. Nowadays, the most prominent of the castle's Georgian buildings form the quadrangle that make up the Upper Castle Yard. These include the State Apartments, the east and west cross-blocks and the Bedford Tower. These were all originally brick built with stone dressing. Most experienced considerable alterations – internally and externally – during the nineteenth and twentieth centuries, making it difficult to identify the original eighteenth-century building works.

The State Apartments, on the south side of the quadrangle, is by far the widest of the blocks, with twenty-eight window bays across the front. It is three storeys high with an arched arcade at ground level and a projecting central bay. Here the ground-level arcading is repeated, with a triangular pediment at the upper level. Internally the block has a wide range of government accommodation, including the Apollo Room, Drawing Room,

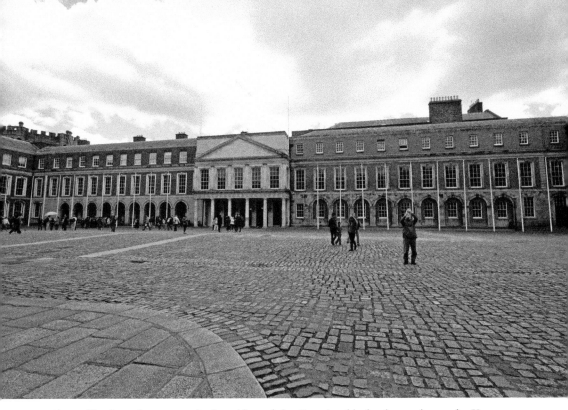

Above: The State Apartments is the widest of the Georgian blocks that make up the Upper Castle Yard, Dublin Castle.

Below: The east cross-block with the triple-arched opening linking the Upper and Lower Castle Yards, Dublin Castle.

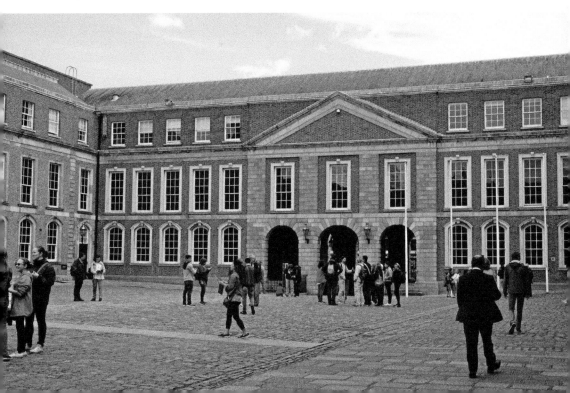

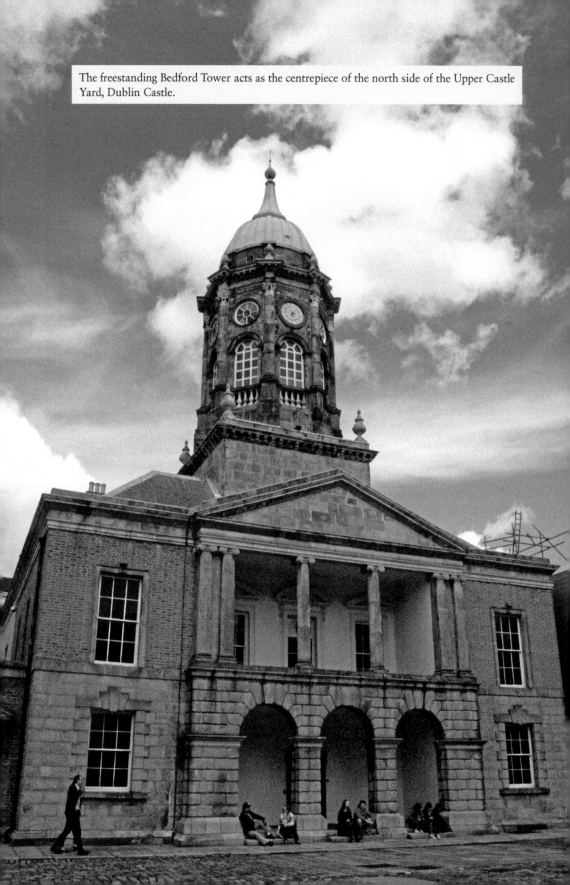

The freestanding Bedford Tower acts as the centrepiece of the north side of the Upper Castle Yard, Dublin Castle.

Throne Room, Picture Gallery and St Patricks Hall. The east and west cross-blocks are mainly in administrative use. They are L-shaped, linked to the state apartments at one end, and enclose the east and west side of the quadrangle. Each is three storeys high with a prominent central bay, a triple-arched opening at ground level and a triangular pediment overhead. The double-storey Bedford Tower acts as the centrepiece of the north side of the quadrangle. The narrow front has a projecting bay with a triple-arched opening at ground level and an open gallery on the first floor. The bay is flanked on either side by a single tall window on each level. On the roof is an octagonal clock tower with round-headed windows on each face and a domed top.

13. Leinster House, Kildare Street

Leinster House was originally built in 1745 as the town house for James Fitzgerald, who subsequently became the Duke of Leinster. The architect was Richard Castles and the building was aligned on an axis to the centre line of Molesworth Street. This was a town planning strategy that was used again and again when positioning important buildings in Georgian Dublin. In 1815 the Royal Dublin Society took over the house and used it as their headquarters, and in 1860 the National Library and the National Museum buildings were built on either side of the house. In 1924 the Irish government acquired the house for use as the seat of government: Dáil Éireann.

The three-storey house has a rectangular plan with a forecourt to the front. There are rectangular Georgian sash windows on each level, rusticated masonry at ground level and plain ashlar on the upper levels. The house has a central bay with the doorcase in the

Leinster House was laid out on an axis to Molesworth Street.

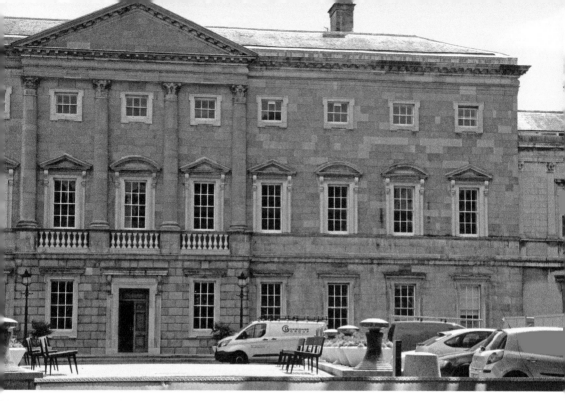

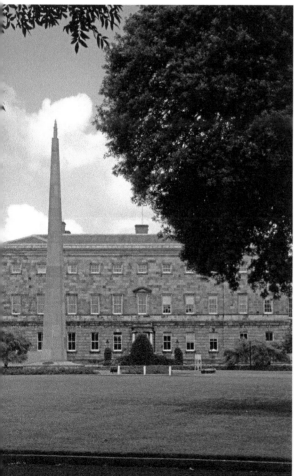

Above: The stone-fronted elevation of Leinster House.

Left: The rear elevation of Leinster House, with its tall granite obelisk, looks out onto Leinster Lawn.

centre, and the upper levels divided into three window bays by columns. Various alterations were made to the house interior by the Fitzgeralds, the Royal Dublin Society and the Irish government over the years. Fortunately, much survives of the original eighteenth-century interior. At one period a statue of Queen Victoria stood in the centre of the forecourt. This was removed and in 1988 transferred to Sydney, where it was re-erected adjacent to the Queen Victoria Building. The rear elevation of the house is much plainer and has a projecting double-window pavilion at either end of the block and a central doorcase. Between the rear of the house and Merrion Square is the landscaped Leinster Lawn. This features a 20-metre-high granite obelisk dedicated to the members of the 1922 Irish government, which was erected in 1950. Although the house is the seat of the government, access is available at certain times.

14. St Patrick's Windmill, Thomas Street

St Patrick's Windmill tower is an unusual survivor of an Irish eighteenth-century industrial building that dates from 1757. It was built for Roe's Distillery that stood in Thomas Street to provided power until the introduction of electricity around 1860. The distillery was sold to Guinness in 1949 and, although had lost its sails and no longer functions, it was eventually transferred to the Digital Hub. The freestanding circular and tapered tower was built with dark brown brick on a square base and was given a copper dome. The structure has a surprising number of window openings. These stretch in a close sequence

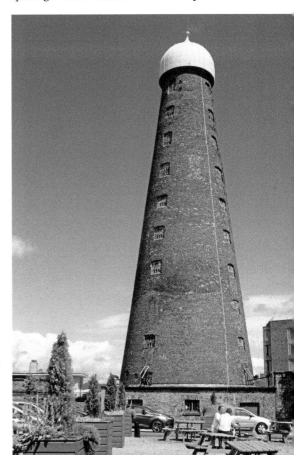

St Patrick's Windmill is a prominent feature of the inner-city skyline.

one above the other from the base to the tower top. The name St Patrick's Windmill was introduced during the nineteenth century when a weather vane with an image of St Patrick was placed over the copper dome. The tower stands in a commercial premises and although there is no public access, it can be seen from an adjoining coffee shop.

15. Rotunda Hospital, Parnell Street

The Rotunda Hospital is a complex building at the intersection of Parnell Street, Parnell Square and O'Connell Street. The hospital was established by the surgeon Bartholomew Moss and was the first maternity hospital to be opened in the British Isles. Richard Castle was appointed architect and construction work began in 1757. The Palladian design of the hospital block bares many resemblances to Leinster House, on which Castle previously worked. This is three storeys high with rusticated and ashlar masonry and a projecting central bay with columns on the upper floors and a roof level pediment. The main area of departure from Leinster House is the inclusion of a three-storey square-based cupola that was built on the roof.

Internally, Castle provided a system of small wards on each floor as well as a magnificently stuccoed chapel on the first floor. This is available for visits on occasions. The hospital block is also flanked on each side by curved and colonnaded side wings and a small

The main elevation of the Rotunda Hospital is similar to Leinster House and fronts onto Parnell Street.

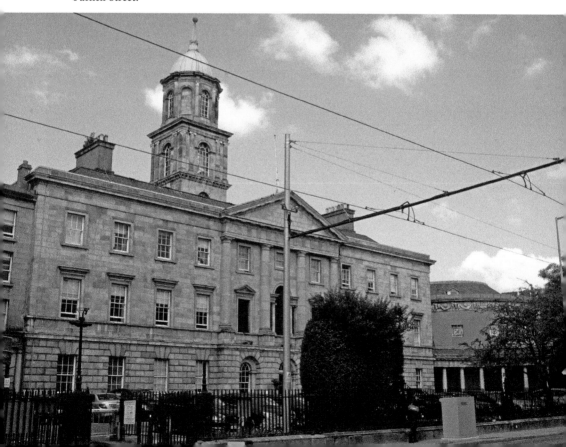

The square base and octagonal cupola on the rooftop of the Rotunda Hospital.

railed-in front garden. The original eighteenth-century complex underwent considerable extensions between the eighteenth and twentieth centuries, particularly when the circular Rotunda Assembly Building and the Gate Theatre were established on the east side of the hospital. As a hospital, public visits to the building are limited.

16. St Catherine's Church, Thomas Street

St Catherine's Church was designed by John Smyth and built in 1760 on the site of an earlier 1150 foundation. The church was taken over by Dublin Corporation and used as an exhibition centre for some time. Unusually, the church returned to religious use 1993. The church was built with its north side opening directly off Thomas Street and axially aligned Bridgefoot Street, which rises steeply from the Liffey Quays. The bold stone elevation is double storeyed with a central entrance bay. This has an arched doorway, a sequence of large round-headed windows, half-columns and a triangular pediment at roof level. On the west side is the uncompleted square clock tower and belfry. The interior of the church has been extensively modified, although the shallow-curved ceiling and upper gallery of the nave survives.

Immediately in front of the church building is a memorial to Robert Emmet, the Irish nationalist and leaded of the abortive 1803 rising, who was hanged and beheaded immediately outside the church. At the rear, the churchyard has been converted to a successful urban park. The church is at times open to visitors.

The bold north elevation of St Catherine's Church on Thomas Street is positioned on the central axis of Bridgefoot Street that rises up from the River Liffey.

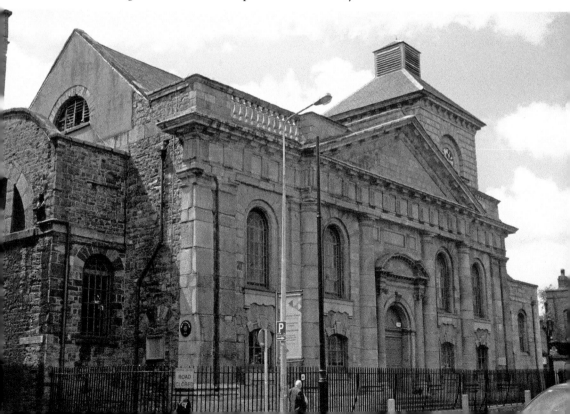

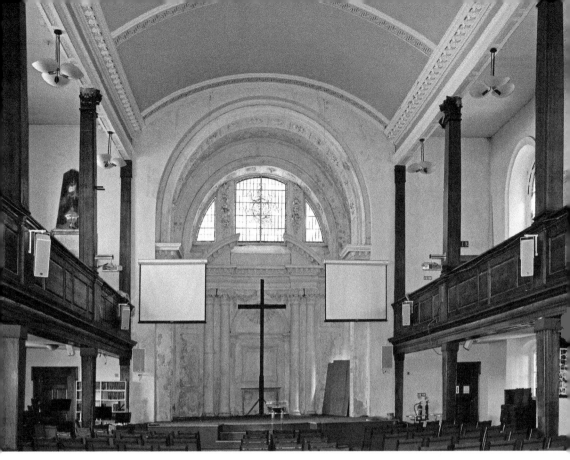

The interior of St Catherine's Church has been modified, but the nave retains its upper gallery and much of its eighteenth-century atmosphere.

17. Hugh Lane Gallery (formerly Charlemont House), Parnell Square

Charlemont House was erected for the Earl of Charlemont in 1763. It was designed by Sir William Chambers as Charlemont's town house, with accommodation for his collection of art and antiques. The house was purchased by the government in 1870 for offices and in 1933 it was purchased by the Dublin Corporation and converted to the city's municipal art gallery. In 2006 the building was extended, particularly at the rear, although some of the eighteenth-century fabric was retained. Chambers gave the three-storey house a symmetrical stone Palladian front with an open porch at ground level. The porch includes a central round-headed door with a pair of columns on each side. Above this, the elevation has five sash windows across the two upper levels. The house was positioned with a shallow set-back from the main building line of the street, with a pair of curved balustraded wing walls linking the house with the houses on the remainder of the street. There it acts as the centrepiece of the long brick Georgian terrace that overlooks Parnell Square.

One notable feature of the gallery exhibits is the reconstructed studio of the painter Francis Bacon. Bacon, who came from Dublin, died in 1992 and in 2001 his South Kensington studio was studied by a team of archaeologists, which was moved to the gallery piece by piece and reassembled – a remarkable achievement.

Above: The entrance to the Hugh Lane Gallery, where some of the eighteenth-century features survive.

Below: The Hugh Lane Gallery with its shallow setback and wing walls merged into the streetscape of Parnell Square.

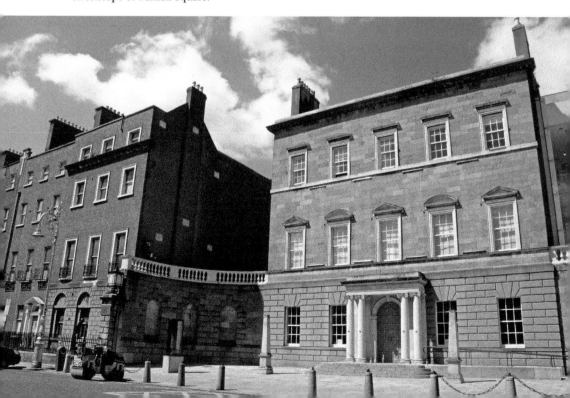

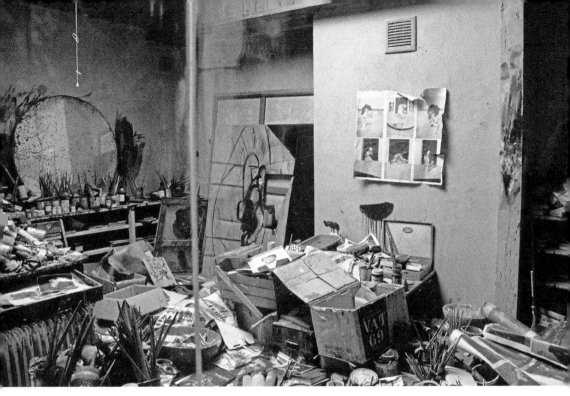

The relocated Francis Bacon's London studio, Hugh Lane Gallery.

18. City Hall, Cork Hill

In 1768 a competition for the design of the Royal Exchange, a place for the city merchants to conduct their business, was held. The winner was Thomas Cooley and a year later work started on the building. In 1850 the building was purchased by the city authorities and in 1852 was designated as the City Hall. During the 1916 Easter Rising the building was occupied by the Citizen Army.

To this day, Cooley's design represents an example of civic pride and remains a powerful presence on Cork Hill. The almost-square stone-built Palladian building is two storeys high with a central bay and two side bays raised on an elevated podium. The central north-facing bay features a bold portico that dramatically lines up with the central axis of Parliament Street, which stretches between the City Hall and Capel Street Bridge. The portico has six powerful columns that support the triangular roof pediment. Each of the side bays has a pair of first-floor sash windows framed with flat columns. The east side elevation has a similar arrangement and faces up Castle Street.

Inside the building, almost the entire ground floor is given over to the circular assembly hall, or rotunda. This has a wide ring of columns that carry a large coffered dome with a central lantern. This was one of the first instances where the dome, a characteristic element of eighteenth-century architecture, made an appearance in the Dublin streetscape. Originally the first floor held coffee rooms, which are currently in administrative use. Underneath the rotunda is the vaulted brick basement, which acts as an exhibition and display area. Overall the building is in exemplary condition, although it is no longer used as the civic centre.

The view of the City Hall from the axial approach of Parliament Street.

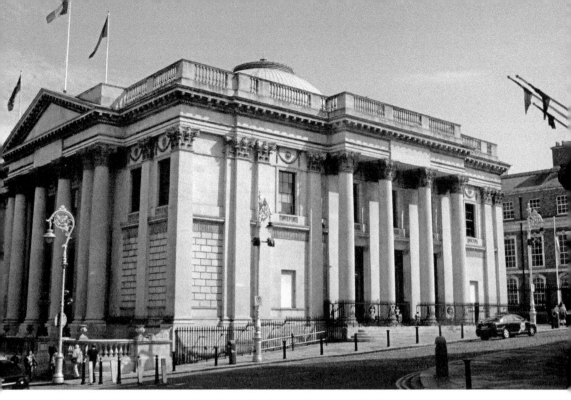

Above: City Hall with the porticos facing Parliament Street and Castle Street respectively.

Below: The rotunda of the City Hall with its wide circle of double-height columns and overhead dome.

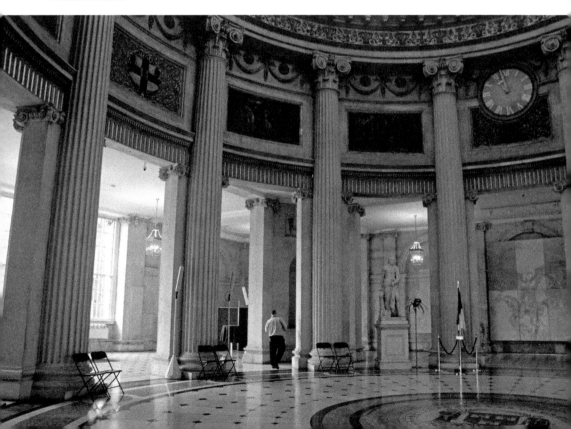

19. Powerscourt House, South William Street

Lord Powerscourt's town house was built in 1771. It was designed by the Scottish architect Robert Mack and laid out flush with the South William Street building line. In 1807 the site was purchased by the government. A few years later Francis Johnson was the architect for three blocks of office that were laid out around the courtyard behind the house. In 1832 the use of the buildings was changed to commercial use. This remained until 1978 when the house and rear offices were converted to a city centre shopping centre.

The wide three-storey house was built with granite drawn from Lord Powerscourt's estate in County Wicklow. This has a central bay, wide entrance steps and a main doorway, as well as round-headed sash windows. The first floor has a tri-part Venetian window, rectangular sash windows and a roof-level pediment. The main block of the house is flanked on either side by single storey pavilion with tall entrance arches and roof pediments. Despite being converted to a shopping centre, much of the excellent eighteenth-century layout, plasterwork and stairs of the house survive and are accessible to the public. At the rear, the brick buildings of the courtyard have been converted to shopping units with access galleries and a glazed roof.

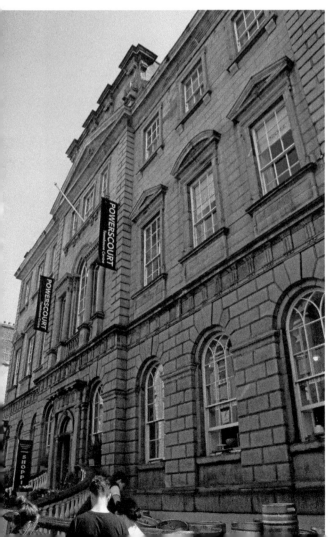

The front of Powerscourt House lines up with the building line of South William Street.

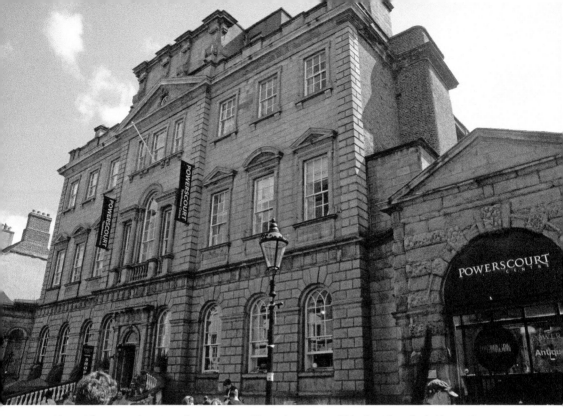

Above: The street elevation of Powerscourt House has a central block with arched side pavilions.

Below: The courtyard of Powerscourt House has a range of shopping units, access galleries and a glazed roof.

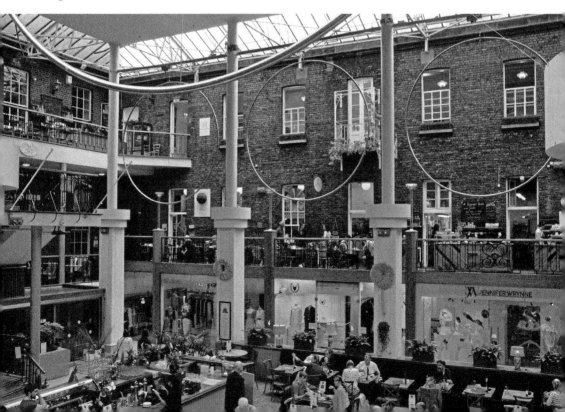

2c. Bluecoat School, Blackhall Place

The Bluecoat School was a charitable school that was originally established in 1671. In 1771 the school building was in poor shape and it was decided to erect a new building. Thomas Ivory was appointed architect and he prepared designs for a large quadrangular school building in Blackhall Place around 1773. Work progressed slowly and in 1780 Ivory resigned; only a single block and the side wings of his initial design had been completed. Ivory's placing of the block was, however, carefully considered as it lines up with the central axis of Blackhall Street, which intersects Blackhall Place from east. The building is set back from the road and has a landscaped forecourt. The school operated until 1978 when the building was purchased by the Law Society of Ireland as their headquarters. The three-storey stone block, with its central bay, columns and pediment, although narrower in width, resembles the Rotunda Hospital block in many ways. The extra dimension was the central octagonal roof cupola, which was added in 1894. This has a tall dome with a top lantern. The single-storey curved side wings provide access to the side pavilions and have blank niches. Both pavilions are double storey with a roof pediment and a large arched window to the front. Each of the pavilions has a tall wooden roof cupola. The north pavilion holds the chapel (now the Presidents Hall) with the library in the opposite side. The internal features of the eighteenth-century building mainly survive. The building is the headquarters of the Law Society of Ireland and there is no public access.

The main block of the Bluecoat School building.

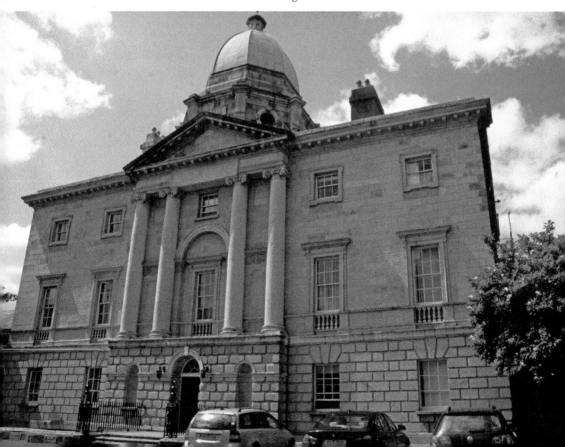

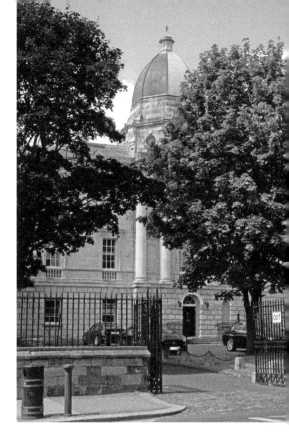

The landscaped forecourt and octagonal rooftop cupola of the Bluecoat School.

The North Pavilion and cupola of the Bluecoat School.

21. Belvedere House, Great Denmark Street

Belvedere House was built for the Earl of Belvedere around 1775, to the design of the architect Robert West and was sold to the Jesuits for use as a college in 1841. The building is four storeys high with a basement and is five window bays wide – a typical arrangement of many of the large mansions around the inner-city area. This includes rusticated stonework at ground level and brickwork on the remaining levels. A short flight of steps provides access to the entrance, where the doorcase has a semicircular fanlight, side columns and a flat roof. One of the significant aspects of the house is its positioning. It forms part of the continuous terraced Georgian streetscape of Great Denmark Street and, at the same time, is aligned on the central axis of North Great George's Street, which rises upwards towards the house. Another significant aspect is the outstanding internal plasterwork that was undertaken by the master stuccodore Michael Stapleton. The building now forms part of Belvedere College with no access to the general public.

Belvedere House is set into the Georgian streetscape of Great Denmark Street and acts as a visual termination to North Great George's Street.

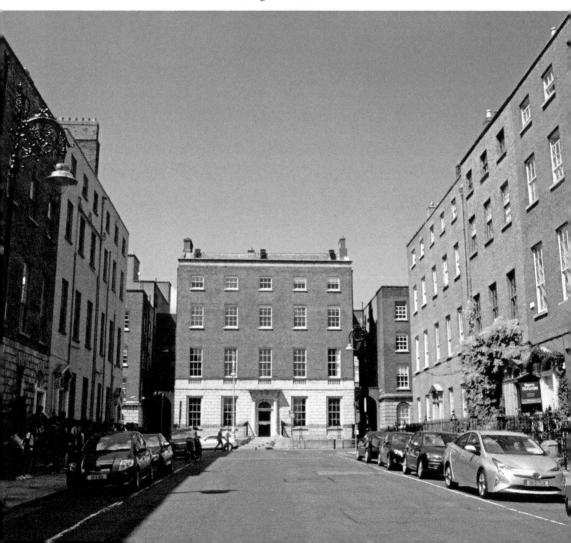

22. Custom House, Beresford Place

In 1780 it was decided to build a new Custom House in Dublin as the building at the time was in poor condition. The commissioner for revenue, John Beresford, decided to relocate the new building on the north bank of the Liffey, well downstream of the previous site. Beresford appointed the English architect James Gandon and in 1782 work on the site began. Gandon went on to become the most significant Georgian architect in Ireland in his day, and the Custom House, which was completed in 1791, remains the outstanding example of eighteenth-century architecture in Dublin. In 1921 the building was burnt during the Irish War of Independence, but by the 1930s the new Irish government succeeded in reinstating Gandon's masterpiece, although with some alterations. The Gandon design consists of a double-storey quadrangle with four corner pavilions and a block between each. The extended north and south blocks face the river and Beresford Place respectively, with the east and west cross-blocks on the shorter sides. The quadrangle contained a central hall that divided the interior into two inner courtyards. The river front, or entrance block, has a large double-height portico, flanked on each side with a recessed bay within a pair of full-height columns. The block has a large double-height portico, which is crowned by tall circular base and a copper dome. The corner pavilions have double-storey recessed porticos and are separated from the central block with an arcade of arches at ground level. The Beresford Place elevation is similar to that on the river front, but the cross-blocks are much simpler in scale. The elevations generally are adorned with a splendid range of figure sculptures, carved keystones representing river-heads and coats of arms. The Custom House is in use as government offices, although access to the interior is occasionally available.

Riverside elevation of the Custom House faces the River Liffey and represents the most accomplished example of eighteenth-century architecture in the city.

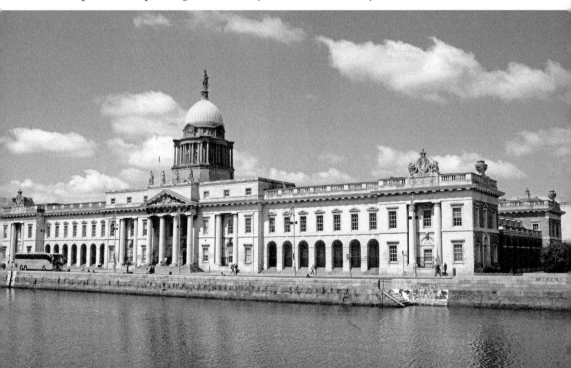

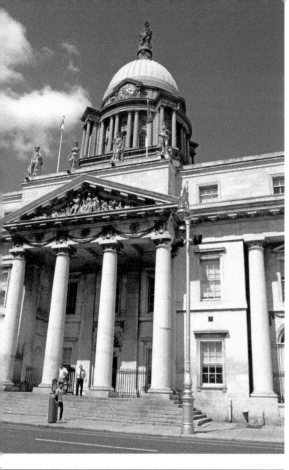

Central block of the Custom House with the double-height portico and great dome.

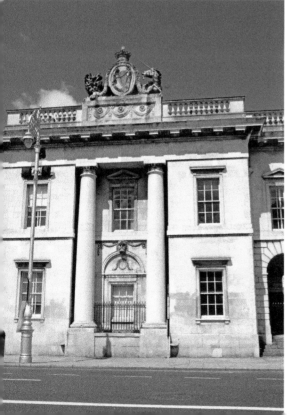

West corner pavilion of the Custom House with its double-storey recessed portico and roof-level coat of arms.

23. Four Courts, Inns Quay

The Four Courts building began as the Public Records Office in 1776 on the north bank of the River Liffey with Thomas Cooley as the architect. Cooley died in 1784 and it was decided instead to house the Four Courts in the building, with James Gandon as the new architect. At that stage the building seems to have consisted of a single block to which Gandon added the courts, hall, dome and quadrangular wings. In 1922 the building was destroyed by shelling during the Civil War. Afterwards the building was reinstated, but it took ten years to complete, with the result that little of Gandon's interiors survives. The building consists of a main three-storey block with a central rotunda, from which four court rooms radiate. In addition two L-shaped blocks extend outwards with a pair of courtyards set in the angles of each block. These are open to the road and riverside, but partially screened by an open arched arcade. The front of the main block that faces the river has a full-height open portico with six columns and triangular pediment, behind which the tall dome sits over the rotunda. The large squat dome rests on a circular base with a pattern of alternating columns and windows, a feature that dominates the building. The building operates as a court and is at times accessible to the public.

The entrance portico of the Four Courts, like the Custom House, faces the River Liffey.

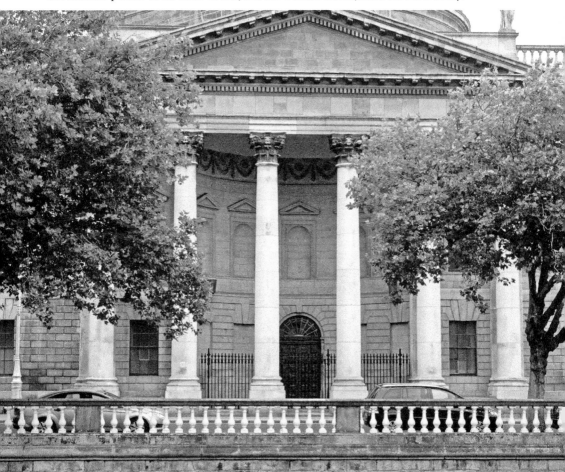

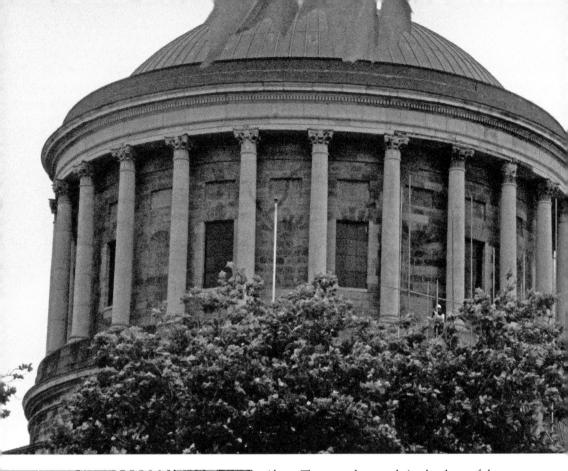

Above: The squat dome and circular drum of the Four Courts, with its pattern of alternating columns and windows.

Left: The portico and courtyard arcade, Four Courts.

24. King's Inns, Henrietta Street and Constitutional Hill

During the eighteenth century the Honorable Society of King's Inns required a new legal headquarters building and James Gandon was appointed architect for the project. The society had acquired the site between Henrietta Street and Constitutional Hill in 1790 and work started on the construction of the new building in 1800. Gandon subsequently resigned his commission and the building was completed in 1817 by the architect Francis Johnston. The building consists of two three-storey elongated and linked blocks, the dining hall, and the Registry of Deeds laid out parallel to one another and separated by a narrow courtyard. The blocks were linked together at one end by a narrow cross-block, resulting in a U-shaped plan arrangement. The principal elevation, which faces Constitutional Hill across the landscaped parkland, features the central cross-block flanked by the two side blocks. The cross-block has three archways at ground level that lead into the courtyard, while the first floor is recessed with blank niches set between paired columns. Above this, the roof caries a cupola has a circle of columns and a copper dome. At ground level each of the blocks has an individual entrance doorway. Interestingly, the door on the left block is flanked on either side by a single caryatid, while each of the blocks has a roof level portico asymmetrically placed to one side. In the centre of the elevation the three archways of the cross-block provide access to the narrow courtyard, at the opposite end of which a triumphal archway, built by Francis Johnson, provides access to Henrietta Street. The building is at times accessible to visitors.

The central and side blocks of King's Inns face onto the landscaped parkland of Constitutional Hill.

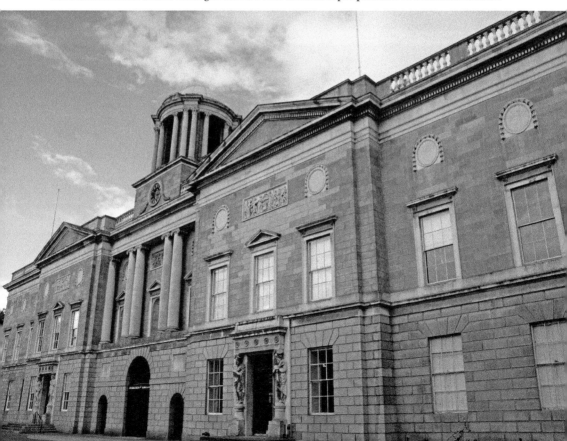

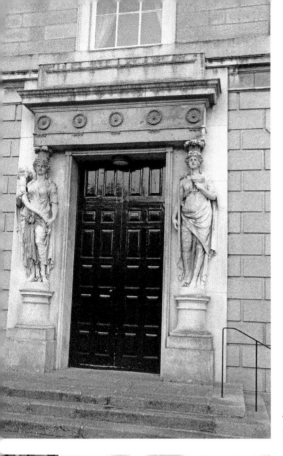

The entrance door to the north block of King's Inns is flanked on either side by a single caryatid.

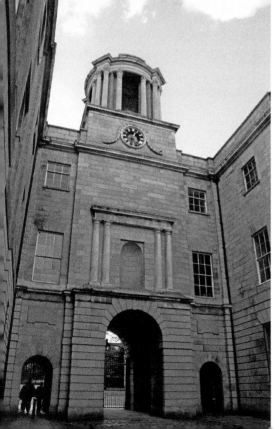

The triple archways of the cross-block provide access to the narrow internal courtyard that separates the main blocks of the King's Inns.

25. St George's Church, Hardwicke Place

Francis Johnston was the architect for St George's Church, which was built in 1802. The church originally acted as a centrepiece of a dramatic urban feature. This consisted of a semicircular crescent that faced the church in addition to three approach roads that focussed on it. Regrettably the eighteenth-century crescent no longer exists. In 1991 the church was deconsecrated and sold for use as the Temple Theatre. The building was sold again in 2004 and was converted to office use. The double-storey stone front elevation faces down Hardwicke Street and has an open double-storey portico with four columns. The remainder of the elevation has tall round-headed sash windows on the upper level and low curved-headed examples at the ground floor.

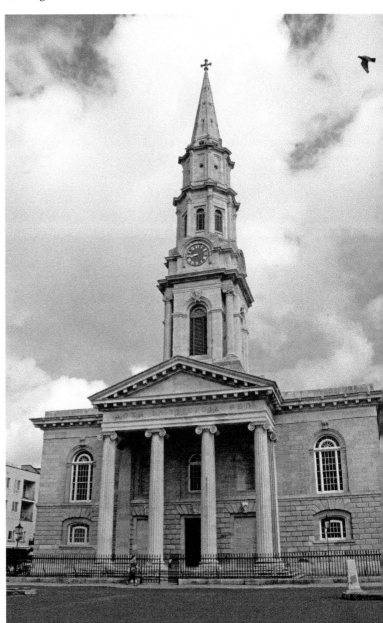

The former St George's Church with its projecting double-height portico and dramatic tower.

The church tower is the outstanding feature of the building with its three levels. The first level is square and originally housed the belfry and the clock, while the upper levels are octagonal and capped with a tall stone spire. The tower is a significant urban element and can be seen from many sectors of the inner city area and beyond. The side elevations of the church are much plainer with window patterns similar to the front. The building is now in office use and with no access.

26. Royal College of Surgeons in Ireland, St Stephen's Green

The Royal College of Surgeons is a medical school with a royal charter that dates from 1784. The original building was designed by Edward Parke and dates from 1805. In 1825 the building was altered and extended in width, by the architect William Murray. Murray's revised double-storey stone elevation opens onto St Stephen's Green and extends across seven window bays. This has square sash windows at ground level and tall round-headed windows placed between columns on the upper floor. The elevation also has a slightly projecting central bay with a pediment at roof level. This central bay also has the ground-level entrance door and side columns set into an elliptical arch, while the roof-level balustrades extend across the entire front of the building. A curious feature of the front

The elevation of the Royal College of Surgeons in Ireland lines up with the east side of St Stephen's Green.

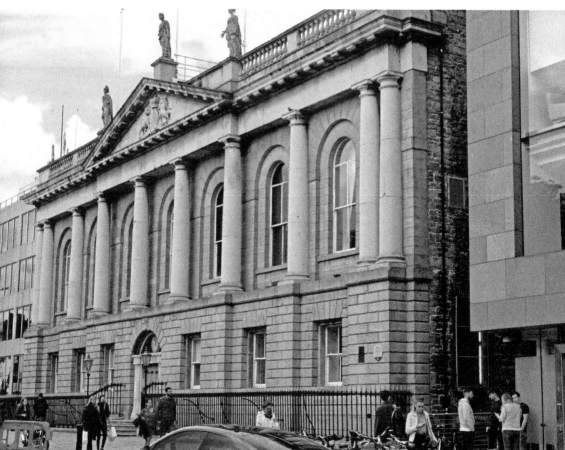

The main door and side columns to the Royal College of Surgeons in Ireland set into the elliptical arch.

elevation is the two fake windows on the upper level, the probable result of achieving a balanced elevation, during the 1825 alterations. Around the corner on York Street, the side elevation has a pattern of rectangular windows on both levels, with semicircular windows on the upper level. The building operates as a medical school with access available only to staff and students.

27. General Post Office, O'Connell Street

The General Post Office was designed by the architect Francis Johnston and built in 1814. It opens onto O'Connell Street, where it projects a powerful impact on the streetscape. It was the command centre of the Republican forces during the 1916 Easter Rising and suffered extensive bombardment. The building was rebuilt in 1924, but only the stone front elevation of Johnson's building survives. This is a three-storey block with a full height central open portico, as well as a continuous rooftop balustrade. The projecting portico has six columns and a triangular pediment at roof level – the latter with three figure sculptures on top. Behind the portico the rectangular windows extend on three levels across the front of the block. Internally the post-rising building houses the public area, a visitor centre, offices, a shopping arcade and an internal forecourt; and is now a political icon because of its part in the 1916 Easter Rising.

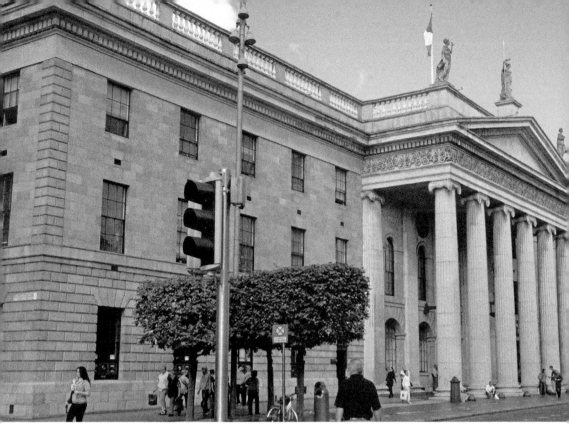

Above: The iconic surviving front elevation and portico of the General Post Office exerts a powerful presence on the O'Connell Street streetscape.

Below: The 1924-built public area of the General Post Office.

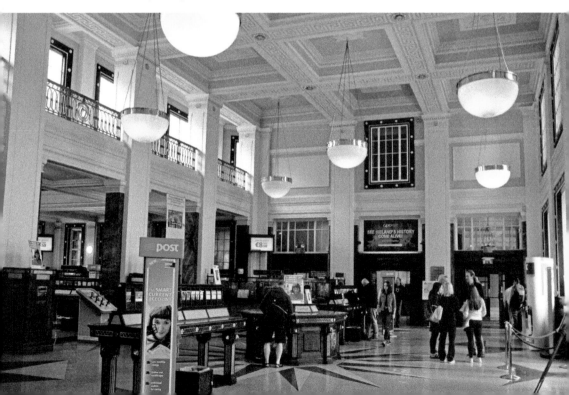

28. Royal Society of Antiquaries of Ireland, No. 63 Merrion Square

No. 63 Merrion Square is typical of the four-storey, terraced brick town houses built all across Dublin during the eighteenth and early nineteenth centuries. This particular house was built for Joseph Sandwich in 1787 and like most of the other Dublin town houses of the period had no architect. Instead, the builder relied on the common building design practices of the period. No. 63 subsequently passed through a succession of owners, including the Shankey family, from whom the Royal Society of Antiquaries of Ireland purchased the house for their headquarters in 1919. The main feature of the street elevation is the entrance doorcase. This has an overhead fanlight and side lights and is set into a semicircular arch. The doorway is approached by a short flight of steps over the open basement area, which is screened by decorated metal railings that extend across the full width of the house. Internally the house layout follows the standard Georgian arrangement of two rooms on each floor: one to the front and one to the rear. These were originally family rooms, although the society now uses the spaces to provide offices, a library and a lecture theatre. Like the other Georgian houses in the city, No. 63 has a long narrow rear garden with a stable mews at the end. Both have now been restored to their original Georgian form. The mews is, however, unusual in that it is the only one in the city where horses continue to be stabled. The building is at times open to the public.

The offices of the Royal Society of Antiquaries of Ireland: part of the uniformed terrace of standard Georgian houses.

The standard Georgian doorcase of the Royal Society of Antiquaries of Ireland with the side windows and fanlight set into a semicircular arch.

Corner post of the typical Georgian metal railings that front the Royal Society of Antiquaries of Ireland building.

29. Georgian Museum, No. 29 Fitzwilliam Street

No. 29 Fitzwilliam Street was built John Ussher as part of the development of the Fitzwilliam family lands. It was initially leased to Mrs Olivia Beatty in 1794 and later in 1806 to John Ponsonby. By 1848 Arthur O'Hagan was using the house in connection with his legal practice and in 1928 the Electricity Supply Board (ESB) purchased the house for office use. In 1980 the board initiated a restoration programme and in 1991 the house was opened to the public as No. 29 – the Georgian House Museum. The house design follows the standard brick-built Georgian town house arrangement of four storeys over the basement. This includes the semicircular doorcase and the vertically proportioned upper windows. Internally the house is decorated and furnished in line with the Georgian ideals of the period, including the basement kitchen, the ground-floor dining rooms, the first-floor drawing rooms and the upper bedroom floors. It gives the visitor the opportunity to experience the eighteenth century family based interior as it originally existed. The museum was closed in 2017, while construction of new ESB offices are being undertaken next door and is scheduled to reopen to the public in 2020.

The standard tall brick-fronted elevation of No. 29 the Georgian Museum, with the arched doorcase and upper-level, vertically proportioned sash windows.

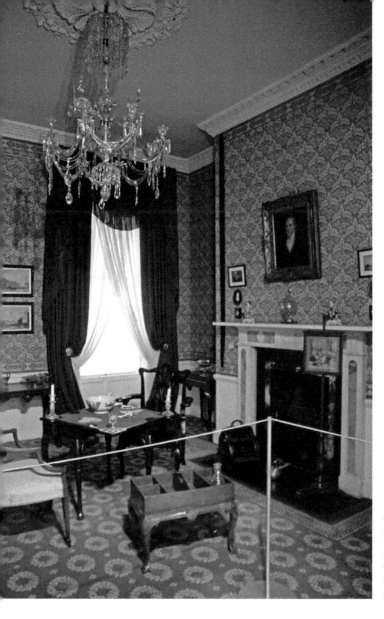

The drawing room of No. 29 the Georgian Museum, restored, decorated and furnished to eighteenth-century expectations.

30. St Mary's Pro-Cathedral, Marlborough Street

St Mary's Pro-Cathedral is positioned on the corner of Marlborough Street and Cathedral Street and with the main entrance front opening onto Marlborough Street. The site was acquired by the Catholic Church to build a new church in 1803 and an architectural competition was held to choose a design and architect. Although a winner of the competition was selected his name was never revealed. Construction started around 1812 and the church was opened in 1825, when it was designated as the acting, or Pro-Cathedral. This was to act as the city's Catholic cathedral until such time as one could be built. This was never done and today the building effectively acts as the cathedral. A number of alterations were made during the construction period, including the addition of a dome

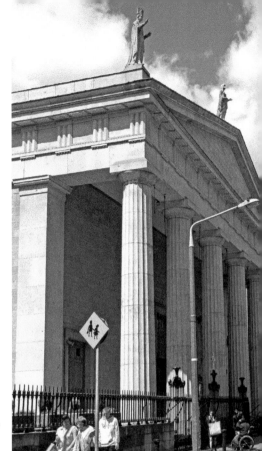

Right: The dramatic portico of St Mary's
Pro-Cathedral opens onto Marlborough Street.

Below: The side elevation of St Mary's Pro-Cathedral,
with its columns and windows, faces onto
Cathedral Street.

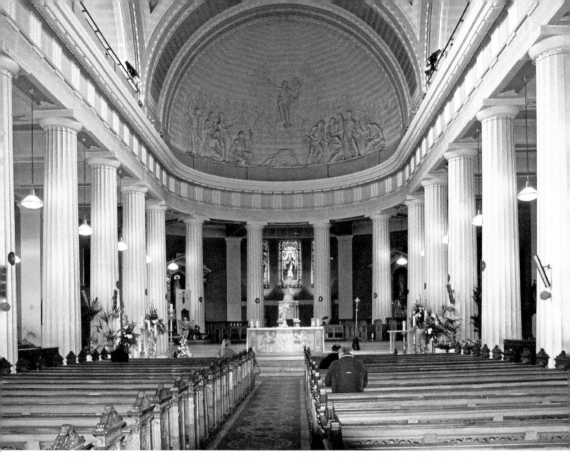

The nave of St Mary's Pro-Cathedral is separated from the side aisles by circular columns.

and the stone Marlborough Street portico. The latter was built in 1834 and designed by the architect John B. Keane. This is a dramatic full-height open portico with six columns and an overhead pediment crowned by three figure sculptures. Round the corner the Cathedral Street elevation has three bays. The centre bay has a pattern of alternating half columns and tall windows. The two outer bays each have a central tri-partite window in an otherwise plain masonry wall. The internal arrangement consists of a nave with double-side isles separated by circular columns that extend around the altar. Overhead the ceiling is gently curved and the dome is positioned in front of the high altar.

31. St Stephen's Church, Mount Street Crescent

Affectionately known as the 'Pepper Canister Church', St Stephen's provides a closing vista to the Georgian streetscape of Upper Mount Street. The church was built in 1824 and designed by the architect John Bowden. The front elevation has a recessed double-height portico, with a pair of columns and a pediment. The prominent clock tower over the portico has a square base and a circular domed copula. The interior is plain with double-level windows and an upper-level gallery. The nave was extended and a semicircular apse was added during the 1850s. The interior of the church remains intact, although the upper-level gallery is no longer in use.

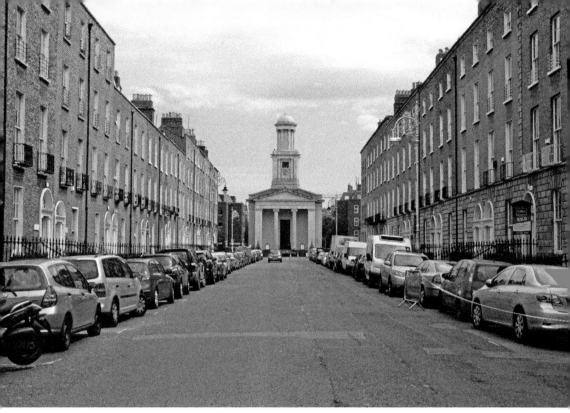

Above: St Stephen's Church is aligned on the approaching central axis of Upper Mount Street.

Right: The double-height portico and tower of St Stephen's Church, with the plain side elevation.

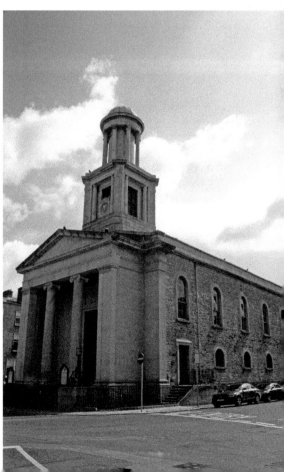

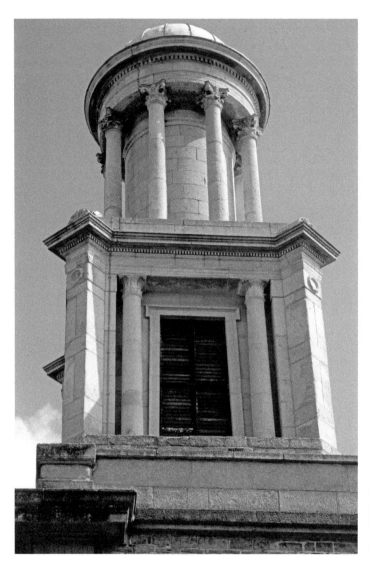

St Stephen's
Church tower with
its square base,
circular drum and
domed cupola.

32. Nos 6 and 7 Harcourt Terrace

Harcourt Terrace is the only block of Regency terraced houses in the inner-city area. The terrace of ten semidetached stucco houses was laid out in 1830 by Jean Jaspar Jolly. The central block – Nos 6 and 7 – is four storeys high, while the remainder of the houses are three storeys. The central block has a projecting portico of four double-height columns, with blank niches in a centre position. In addition, the niche motive is repeated on the third level as well as an oculus on the top floor. Elsewhere the sash windows have a vertical emphasis. The houses are in office use and have a conventionally arrangement of residential accommodation. The front gardens are landscaped and access to the houses is not available.

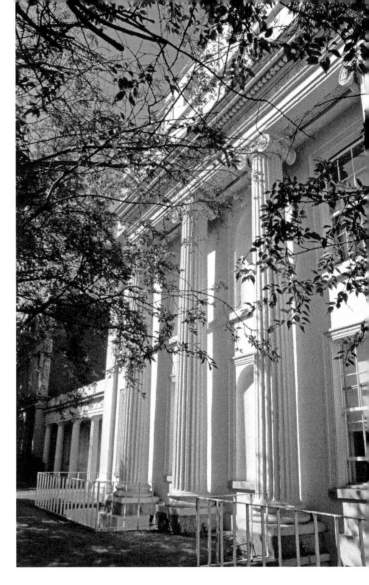

The front Regency elevation of the Harcourt Terrace central block with double-height columns and blank central niches.

St Audoen's Church in High Street, immediately adjoining the medieval church of the same name, projects its plain but massive masonry wall to the much lower Cook Street. Work started on the building in 1841 and was designed by the architect Patrick Byrne, marking it as one of the final buildings completed in the Georgian era. The building has a forecourt to the front and the portico, added in 1898, was designed by George Ashlin. Earlier in 1861 the church organ was installed in the upper gallery. The impressive front open portico is an imposing structure with four tall columns that support a pediment. The internal layout has a large nave with wide transepts on either side of the altar. The interior throughout has panelled walls, round headed niches and an elaborate vaulted and panelled ceiling. A section of the ceiling collapsed in 1880 and the site is now marked by a large circular ceiling panel decorated with an elaborate floral design.

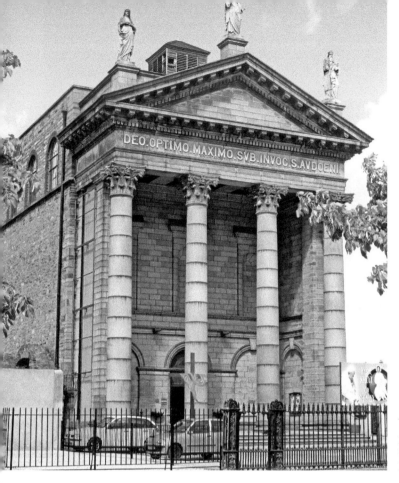

The full-height open portico of St Audoen's Church faces onto High Street.

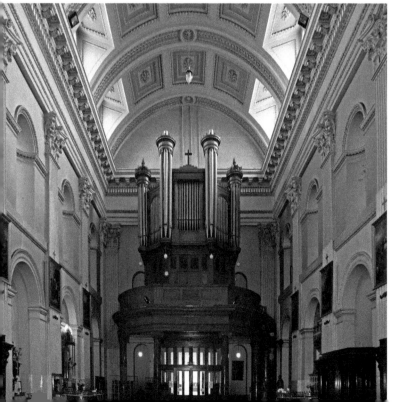

Interior of St Audoen's Church with panelled walls, vaulted ceiling and church organ.

34. Chapel Royal, Cork Hill

The Chapel Royal was the Church of Ireland chapel for the Lord Lieutenant's household in Dublin Castle. The chapel was built at the east end of the state apartments, abuts the Record Tower and acts as the south side of the Lower Castle Yard. It was designed by the architect Francis Johnston and work started in 1807. It was the first introduction of the Gothic Revival style to Dublin. That is, it set out to reintroduce the Gothic architecture of the medieval period and incorporated most of the characteristic Gothic features, including buttresses, pointed doors and windows, as well as carved heads and rooftop battlements. An added feature of the Chapel Royal is the range of vibrant sculptured heads incorporated into the external masonry. Internally the accommodation consists of a nave, side pews and an upper level gallery notable for the fine plasterwork. Here the columns and vaulting are executed in stucco fixed to timber framing – the work of George Stapleton. The vaulting in particular offers a most outstanding example of plasterwork and includes some delightful human faces in the ceiling of the side pews. In addition, the names and coats of arms of the various Lord Lieutenants who served in the castle are featured on the face of the upper gallery. The chapel was deconsecrated and now acts as one of Dublin Castle's visitor attractions.

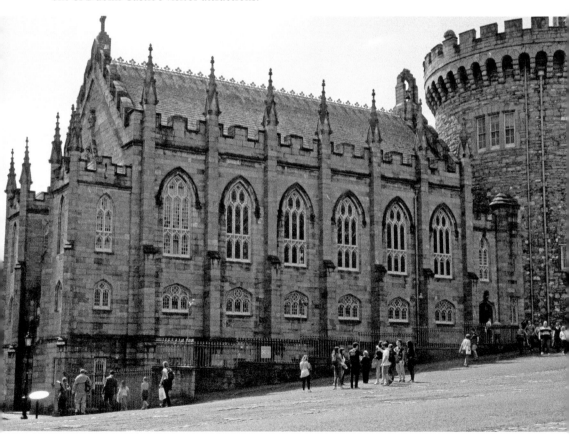

North elevation of the Chapel Royal, including buttresses, Gothic windows and battlements.

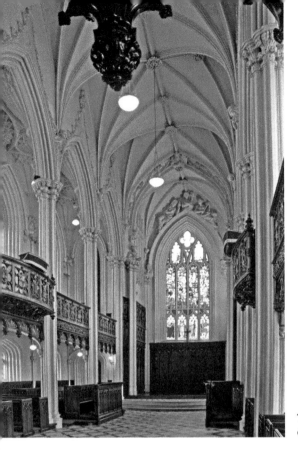

The nave, side pews and upper gallery of the Chapel Royal.

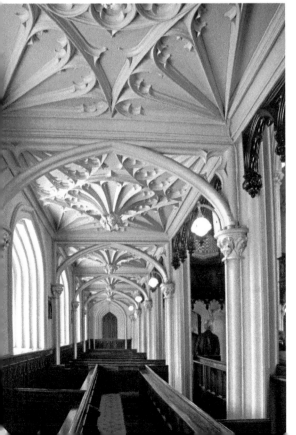

Pews and stucco work of the Chapel Royal.

35. Nos 36 and 37 Heytesbury Street Terrace

Heytesbury Street Terrace is a typical example of Victorian terraced houses built around inner-city Dublin from the 1850s onwards. This was a continuation of the Georgian terraced housebuilding tradition, but with subtle differences. The double-storey Heytesbury Street houses are narrower and the basement rises completely out of the ground. The basement

The extended
Heytesbury
Street terrace of
double-storey
houses with
their landscaped
gardens.

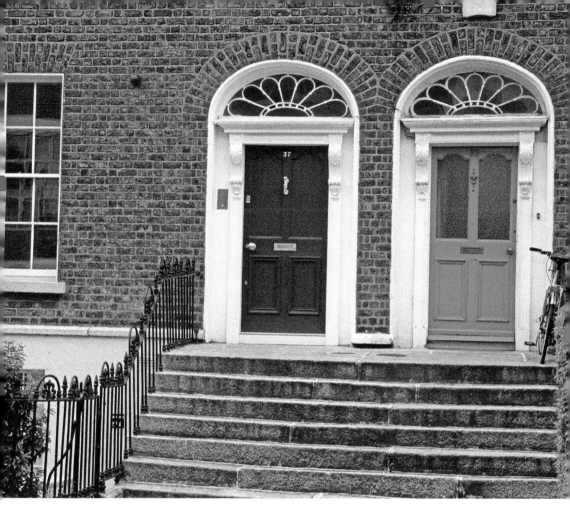

The narrow-fronted Nos 36 and 37 Heytesbury Street with their brick and render elevation and upper-level entrance door.

level is rendered and only the upper level is brick built. The basement level contains the kitchen and dining room, while the upper level has the living room and bedrooms. For this reason the entrance door is positioned on the upper level and approached by a tall flight of steps – an elevation treatment with a unique Dublin twist. This effectively focuses attention on the upper level of the house. For the first time the houses also include a landscaped front garden, separated from the footpath with a gate and metal railings. The houses are all in private ownership and access is unavailable.

36. Heuston Station, John's Road/Victoria Quay

In 1846 the Great Southern and Western Railway built the cast-iron train shed that housed the terminus for the south of Ireland rail line, following which they held a competition to design their offices. Santon Woods, an English architect, gave the company a design based on an Italian palace and won the competition, on which construction started in 1848. Wood's tall double-height building consists of a single block with low

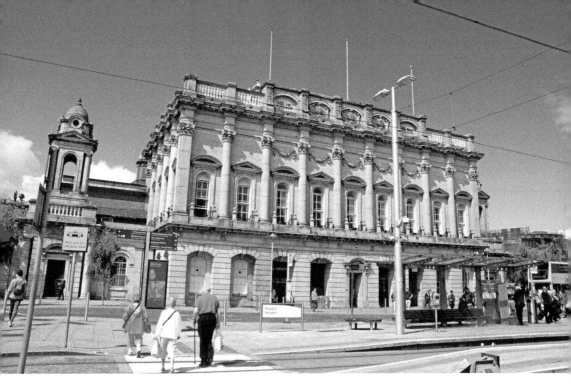

Above: The palace-like entrance elevation of Heuston rail station.

Right: The corner pavilion with the entrance, cupola and open base.

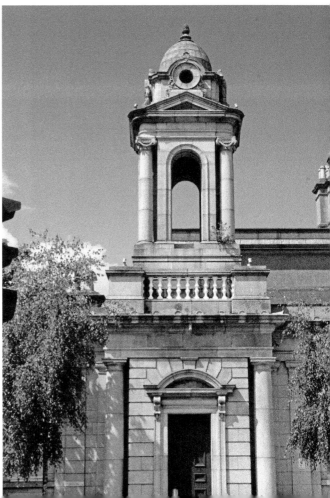

side wings and tall corner pavilions, the latter with entrance doorways and a cupola on an arched open base. On the south side of the main block the line of the side wings was continued along the side of the train shed, with a long block of round-headed windows and an arcaded entrance porch. This provided an entrance to the train platforms. The main block was given the full Italian Renaissance treatment: a series of ground-floor windows and openings, arched windows with pediments, extended columns between each window, and swags linking the central columns at high level. Overhead the almost hidden attic level has low curved windows flanked by balustrades. The ground level of the rail terminus is open to the public, but the upper floors of the office accommodation are not.

37. Gate Lodge, St Stephen's Green

The Gate Lodge to St Stephen's Green was designed by James Franklin Fuller. It was built around 1889 in the Picturesque style and is the only example of the Picturesque movement in the inner-city area. This was a Romantic movement that sought to recreate architectural styles and elements of the past. Among the Picturesque elements that Fuller included in the

The Picturesque-style elevation of the St Stephen's Green Gate Lodge.

elevations of the Gate Lodge were: an irregular form, brick walling, gabled and hipped roof lines, decorated barge boards, and wall tiling. The lodge is a private dwelling with no public access.

38. Museum Building, Trinity College

In 1833 Trinity College held a competition for the design of the new museum building. Twenty years later the architects Dean & Woodward were chosen as winners and the building was completed on the north side of the landscaped New Square. Dean & Woodward's design, which drew heavily on the ideals of the Victorian art critic John Ruskin, included a large rectangular double-storey block with the arched windows on both levels grouped into triple or double arrangements. This followed the practice of using antique ideas and elements. The windows and entrance door, in particular, display the architect's interest in exploring Venetian Gothic as well as Byzantine elements in their composite use of organic, stylistic and geometric components. Internally the building has a domed central hall, a suite of lecture halls and a museum. The building is part of the college's academic range and is accessible only to college students.

The north or entrance front of the museum building faces onto the landscaped New Square, Trinity College.

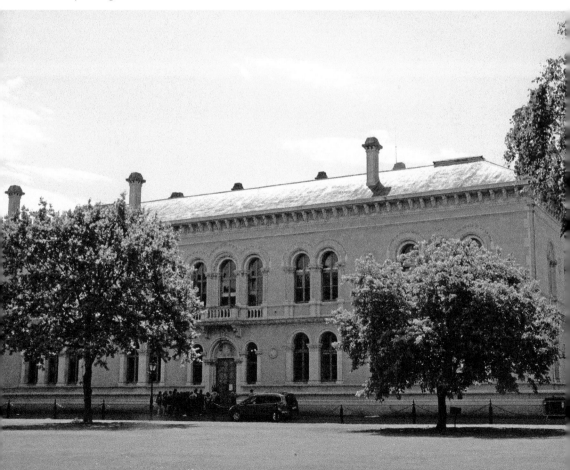

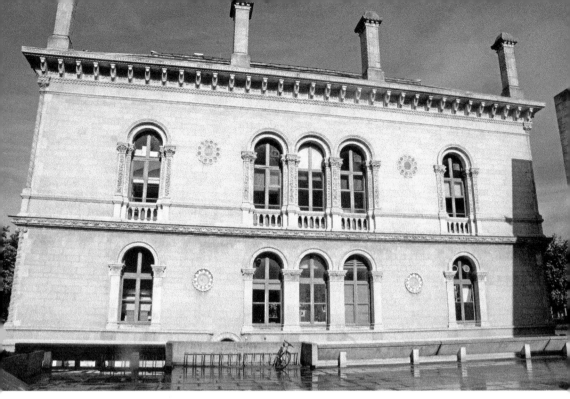

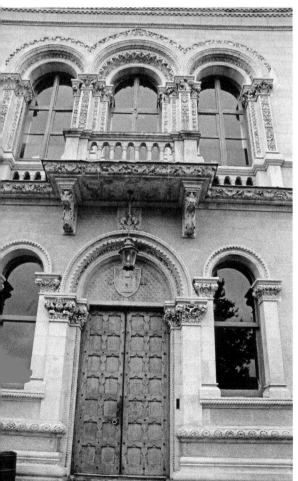

Above: The east elevation of the museum building faces onto the library podium.

Left: The round-headed windows and doorway of the museum building have a historic reference to Venetian and Byzantine architectural ideas.

39. Newman University Church, St Stephen's Green

Newman University Church was built by Cardinal John Henry Newman in 1855 as part of the Catholic University of Ireland on a site directly behind No. 87 St Stephen's Green, which was accessed by a narrow side passage. The architect was John Hungerford Pollen incorporating a neo-Byzantine style. A year later a narrow entrance porch was built to provide a street entrance to the church. Today the processional layout of the church includes the entrance porch, the atrium, the ante-church, the nave and the sanctuary. The entrance porch is the only external face of the church. It follows Pollen's Byzantine ideal and has a semicircular brick arch springing from a double pair of Byzantine columns. Immediately behind the pitched roof is a small overhead belfry. The atrium is in effect a long plain passageway that leads to the ante-church. The low ante-church was fitted below the church gallery and consists of a cluster of arches and columns, which were necessary to support the overhead gallery. This provides an atmospheric view of the nave beyond. The nave is a blaze of colour, wall painting, an arcade of coloured marble panels, rich wall paintings, high-level windows, and a flat decorated ceiling. The sanctuary at the end of the nave has an elaborate altar covered by a high-level hood, with the entire area sitting beneath a half dome – all treated with brightly coloured marble and mosaics.

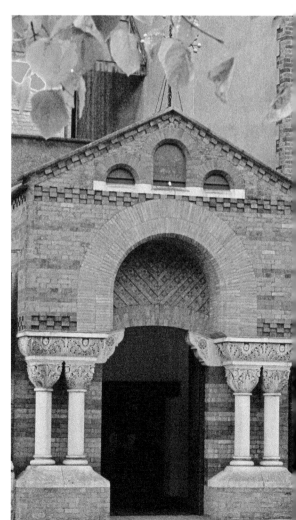

The Byzantine entrance porch is the only element of Newman University Church appreciable from the street.

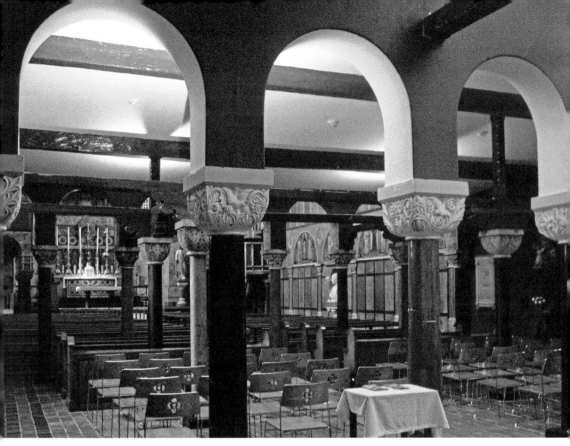

Above: The columns and arches of the ante-church offer an introductive view of the nave of Newman University Church.

Below: The nave of Newman University Church has a rich range of materials and colours.

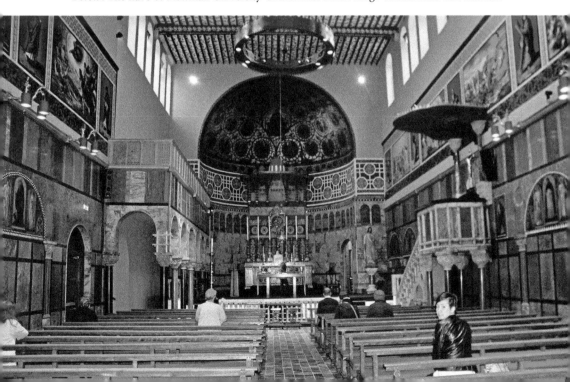

40. Former Kildare Street Club, Kildare Street

Founded in 1782, the Kildare Street Club decided to build a new clubhouse on their site on Kildare Street. The architectural firm appointed to design the new premises was Dean & Woodward. The result was a three-storey L-shaped brick building that turned the corner into Leinster Street and where work started in 1859. In 1971 the building was subdivided and most of the nineteenth-century interiors were replaced. Later in 1976 the club merged with the University Club and vacated the premises.

The building is in a restrained neo-Byzantine style with extensively brickwork, pronounced window heads and stone string courses at various levels. The Kildare Street side has a tall triple-arched entrance porch and a first-floor balcony, with a double-height bay window on the Leinster Street side. An unusual feature is the small first-floor balcony adjacent to the street corner. Elsewhere, the ground- and first-floor windows are grouped into double and triple arrangements, with stone columns between the openings. Curiously, the plain top-floor windows do not align with the lower groupings. Another notable, but often overlooked, feature of the building is the stylistic animal carvings, such as the billiard playing monkeys, at the base of the window columns. Nowadays the building is in commercial use, although parts remain accessible to the public.

The former neo-Byzantine-style Kildare Street Club dominates the corner of Kildare Street and Leinster Street.

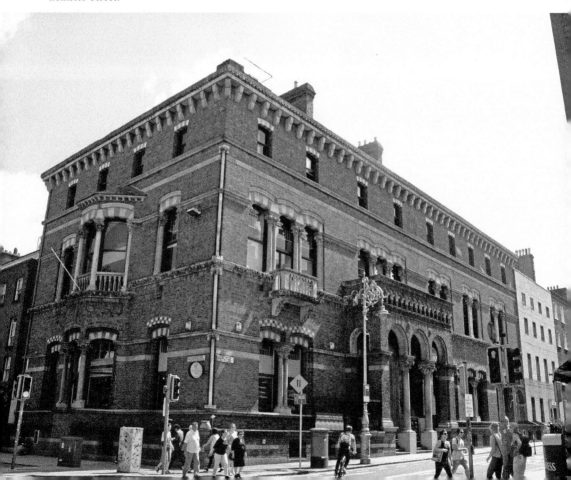

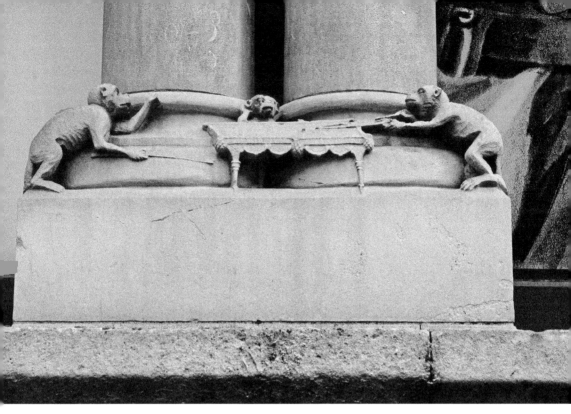

Carved stylistic monkeys playing billiards at the base of the window columns of the former Kildare Street Club.

41. St Augustine and St John's Church, Thomas Street

The church of St Augustine and St John, or 'John's Lane' as it is affectionately known, was built by the Augustinian Order in 1862 at the corner of Thomas Street and John Street on the site of the medieval hospital of St John. The surviving remains of the hospital were removed and Pugin and Ashlin were appointed architects and produced a vibrant Gothic Revival church. The progress on the work was slow and in 1874 the tower was completed, although it was not until 1911 that work on the church was completely finished.

The church was built in granite with red sandstone string courses and dressing and represents one of the most flamboyant examples of Irish Gothic Revival. The church's dramatic street elevation has a tall central tower flanked by side bays, all decorated with a range of elaborate Gothic Revival elements. The base of the tower forms the tall arched entrance doorway with an overhead gable. Above this, the slim wedge-shaped tower rises over 60 meters with a complex sequence of arches, gables, niches, carvings and figure sculptures. At its top, the tower is crowned by an unusual wedge-shaped spire – a striking feature on the city skyline. The side elevation on John Street has a sequence of Gothic windows and overhead gables. Internally the church layout has a nave, side isles and a semicircular sanctuary. Here the combination of the soaring height, the pointed arches of the arcade, the slim circular columns, the tall pointed side windows, the elaborate ceiling vaulting, the mosaic tiling and the stained-glass windows represent an outstanding example of the Irish Gothic Revival.

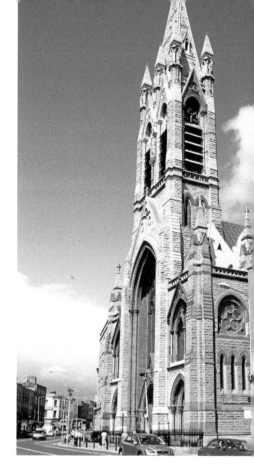

The Gothic Revival front of St Augustine and St John's Church, with its mixture of granite and sandstone trimming, opens directly onto Thomas Street.

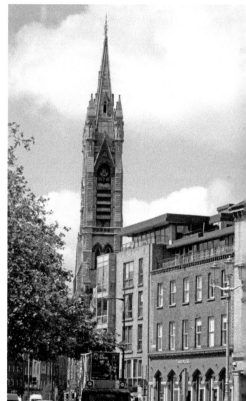

The tower and wedge-shaped spire of St Augustine and St John's Church have a significant impact on the city's skyline.

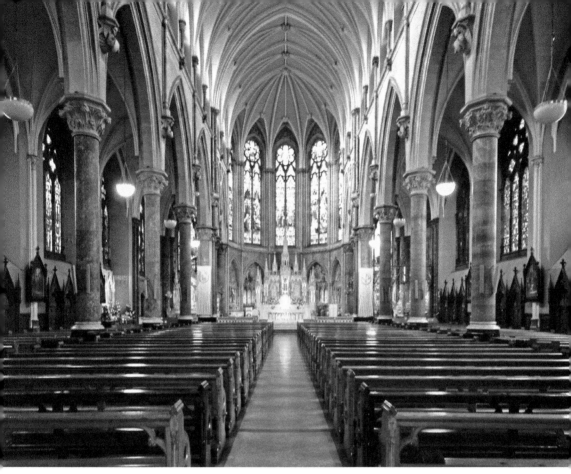

The interior layout and finishes of St Augustine and St John's Church mark a highpoint in Irish Gothic Revival.

42. South City Markets, South Great Georges Street

The Dublin South City Markets Co. held a competition for their new market building in South Great Georges Street around 1876. The winners were the architects Lockwood and Mawson and they produced a three-storey baronial-style brick and terracotta design, complete with towers and corner turrets. Work started around 1878 and had a glazed central court with shopping units distributed around the perimeter of the site. In 1892 the building was badly damaged in a fire and was reinstated by the architects W. H. Byrne, on the basis of the original design, with modifications. Byrne remodelled the interior on a cruciform arcade plan, with a metal roof and high-level glazing, although one of the arms was subsequently built over.

Today the market, or George's Street Arcade as it is commonly known, is bounded by Exchequer Street, Fade Street and Drury Street. The basement is used as a car park, while the shop units on the ground level extend around the perimeter of the site, with a range of shopfronts. Overhead the two upper floors have curved window heads with gabled dormer windows in the attic. The block has a series of pavilions. The gabled South George's Street entrance pavilion has corner turrets, a double-arched entrance and a high-level

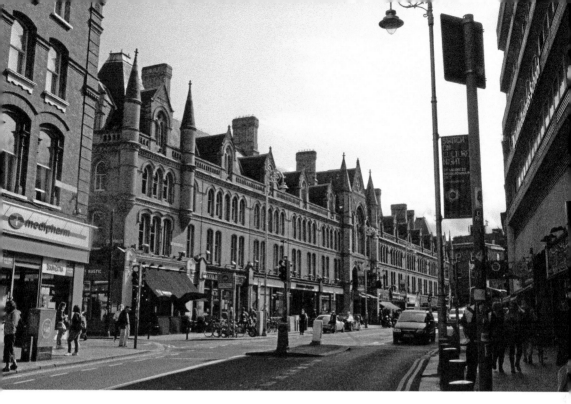

Above: The main front of the South City Markets extends along the streetscape of South Great George's Street.

Right: The corbelled turrets and attic window of the South City Markets' corner pavilions.

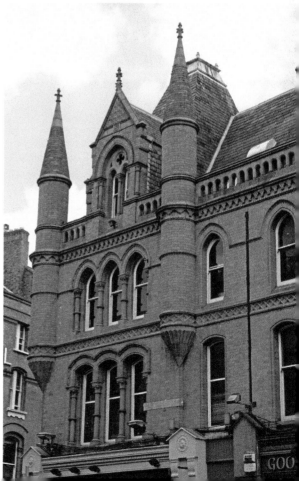

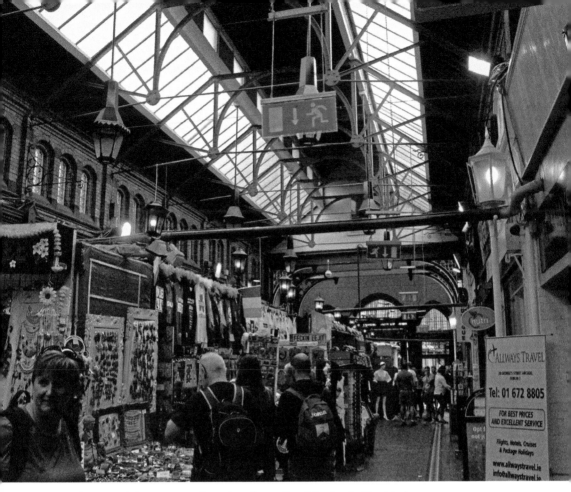

The internal shopping arcade and market stalls of the South City Markets.

pointed-arched window. The Drury Street entrance is more modest with a triple-arched entrance. The corner pavilions have shopping at ground level, overhead corbelled turrets and gabled windows. Internally the arcade is lined with shop units as well as a central bank of market stalls. The upper levels throughout are in office use with no public access, although the ground-level shopping is fully accessible.

43. Sunlight Chambers, Parliament Street

Sunlight Chambers was built on the corner of Parliament Street and Essex Quay as the Dublin headquarters of Lever Brothers in 1899. Sunlight refers to a soap manufactured by the company. The architect was Edward Ould and consists of a four-storey Italianate-style office building over a basement. The ground level has a bracketed portal entrance doorway and round-headed windows. The first-floor windows are rectangular, the second-floor windows are round headed, and the top floor has a low arched arcade. Above this is the over sailing bracketed eaves. The single most notable feature of the building is the glazed terracotta panels that stretch across the building on two levels. The upper panel shows workers undertaking physical work, while the lower panel shows ladies and children

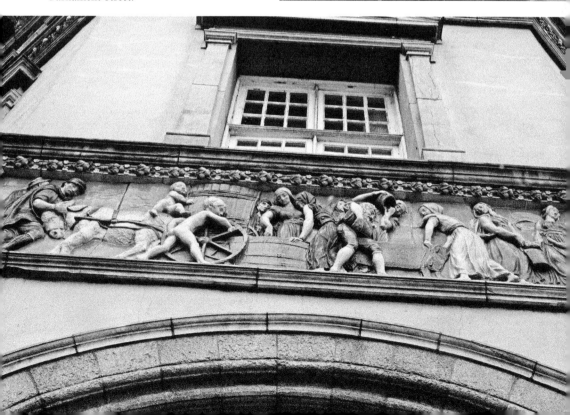

Right: The Italianate-styled Sunlight Chambers office building on Parliament Street corner with the two levels of glazed panels.

Below: The lower level of glazed panels depicting manual work on the Sunlight Chambers office building on Parliament Street.

engaged in washing and drying – all presumably referring to the merits of Sunlight soap. In its early years the building was referred to as the 'ugliest building in Dublin'. Today the building is in office use with no access to the public.

44. Royal Victoria Eye and Ear Hospital, Adelaide Road

The Royal Victoria Eye and Ear Hospital was established in 1895 through a merger between the National Eve Hospital and St Mark's Ophthalmic Hospital. A site for the new hospital was purchased on Adelaide Road and Carroll and Batchelor were appointed architects. Work on the brick and stone-banded Queen Anne Revival-style building started in 1901, with later additions in 1907 and 1912. The building is two storeys high with a basement and an attic. It has a long, but narrow, central block with forward projecting side wings on either side. The central projecting entrance has an arcaded porch and upper-level balcony. Overhead the upper floor levels have a tri-partite window with flanking columns as well as an open, or swan-neck, portico at roof level. The central block has a corner tower at either end with wedge-shaped spires, each one with an octagonal cupola. The building is set in a landscaped site that adds significantly to the hospital environment. Entry to the hospital is reserved for medical staff and patients.

The brick and stone elevation of the Royal Victoria Eye and Ear Hospital.

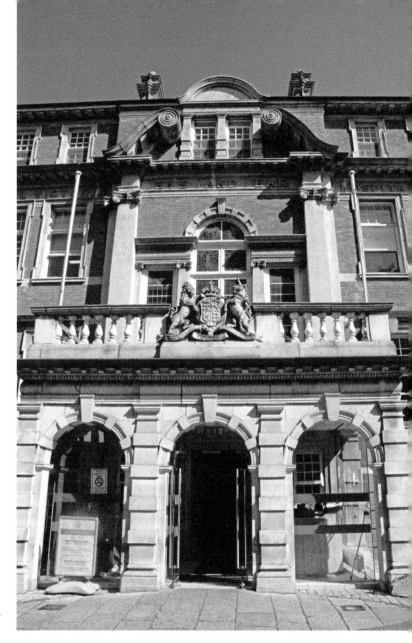

Central entrance
bay with colonnade,
balcony, columns and
Swan-neck pediment,
Royal Victoria Eye and
Ear Hospital.

45. O'Neill's Pub, Suffolk Street

Positioned at the intersection of Suffolk Street and Church Lane, O'Neill's Pub was
built in 1908. George P. Sheridan was the architect and he blended the four-storey over-
basement building into the curve of the street junction. The elevation of the red-brick
building has an arrangement of Picturesque elements, including individual shopfronts,
decorated brickwork, stone string courses, projecting bay windows, roof gables, decorated
bargeboards, and a projecting clock. Internally the pub has a sequence of interconnected
intimate spaces decorated with antique woodwork and finishes.

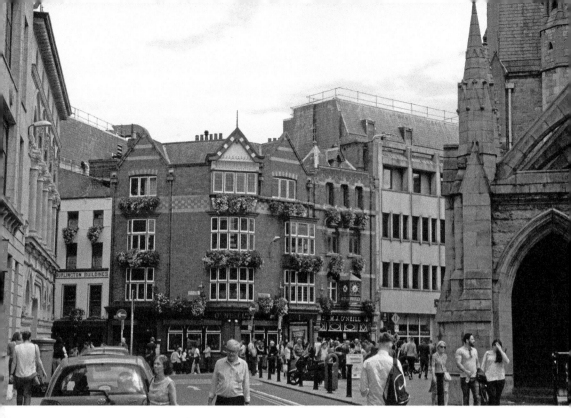

Above: O'Neill's Pub at the intersection of Suffolk Street and Church Lane.

Left: Part elevation of O'Neill's Pub, Suffolk Street, including the shopfront and upper-level brickwork.

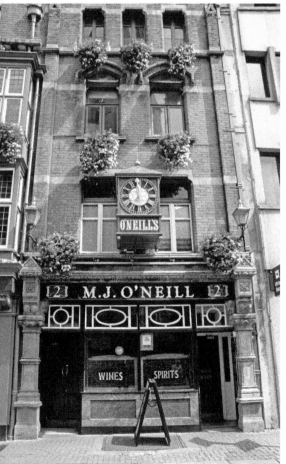

Interior of O'Neill's, with intimate spaces and polished woodwork.

46. Busáras (Central Bus Station), Beresford Place

Busáras, the central bus station for Dublin, was built in 1946 and was the first Modernist International building to appear in the city. The station was designed by the practice of Michael Scott and was based on the ideals of the French architect Le Corbusier. These included the use of reinforced concrete columns, lightweight non-structural glazed curtain walling, as well as the absence of decoration. The building was laid out in an L-shaped arrangement. The taller leg of which stands seven storeys high, while the lower leg is four storeys. In the case of the taller section, the upper level is set back from the main block lines and has a sequence of projecting canopies, in contrast to the plain flat roof of the lower section. In addition to the curtain walling, the block ends are faced with Portland stone. Today, all but the ground level of the station are in office and administrative use and public access is not available. The upper level was originally planned as a nightclub and a theatre was included in the basement area; however, the nightclub was never implemented and the theatre is no longer in use. The glazed bus-boarding area is at ground level and tucked into the angle of the block, with a wide opening at either block end to permit

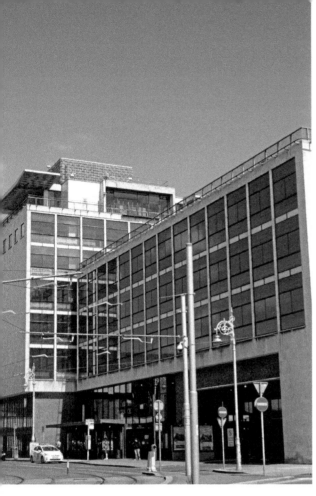

Left: Busáras bus station is the earliest example of the International Modern architecture movement to appear in Dublin, with its absence of decoration and the use of reinforced concrete construction and flush curtain walling.

Below: The ground-level waiting area of Busáras, with its wave-like roof, provides tickets and services to the waiting bus passengers.

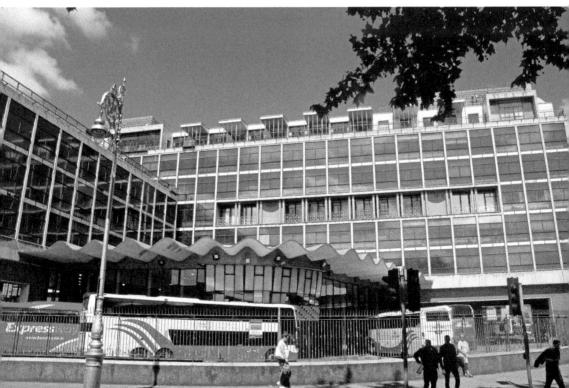

the vehicles to enter and leave the bus park. Also, at ground level, the tall single-storey public waiting area overlooks the parking terminus has a dramatically exaggerated wave-like roof.

47. Berkeley Library, Trinity College

The competition for the Berkeley Library in Trinity College was won by Ahrends, Burton and Koralek and was completed in 1967. The bold geometric building is set on a raised podium and is reached from the Fellows Square and the New Square by a system of stairs and ramps. The concrete and stone building is rectangular in form with exposed concrete at the lower level and large areas of granite masonry overhead. Here the rectangular mass of the front elevation acts as a backdrop to Arnaldo Pomodoro's *Sphere* sculpture. An unusual feature of the design of the block is the windows: pairs of curved glass set into framed recesses in the wall with concrete sills. Internally the building has a double-height reading room with intimate alcoves and galleries, with exposed concrete walling and ceilings. Access to the library is reserved to staff and students.

The side elevation of the Berkeley Library closes the east side of the Fellows Square, Trinity College.

Above: The Berkeley Library on its raised podium, Trinity College.

Left: The curved glazing, mass concrete and stonework emphasises the corner of the Berkeley Library, Trinity College.

48. Former Bank of Ireland Headquarters, Baggot Street

The former Bank of Ireland headquarters was designed by R. Tallon of Scott, Tallon & Walker Architects and was completed in 1972. The design was heavily influenced by the American architect Mies van der Rhoe and consisted of three independent blocks arranged around a paved plaza with one side open to Baggot Street. The two lower blocks are three and four storeys high and face onto the plaza with their ends fronting onto Baggot Street, while the remaining block at the rear of the plaza is eight storeys high. The ground floor of the front blocks is stepped back from the main line of the building with the structural columns sheeted in bronze coloured aluminium. The reinforced concrete frame of the buildings is totally enclosed by the curtain walling – one of the earliest examples of the use of the technique in Ireland. This consists of a flush lightweight bronze-finished skin divided into uniform single panel glazing – all with a vertical emphasis that matches the surrounding Georgian streetscape. The plaza hosts two sculpture pieces: Michael Bulfin's *Reflections* and John Burke's *Red Cardinal*. The complex is in commercial use and is not accessible to the public.

The blocks of the former Bank of Ireland Headquarters building are arranged around the plaza that opens out onto the street.

Above: The vertical bronze-coloured curtain walling, ground-level recess and sheeted columns of the former Bank of Ireland headquarters.

Left: Brightly coloured metal sculpture contrasts with the bronze curtain walling of the former Bank of Ireland headquarters buildings.

49. Millennium Wing, National Gallery, Clare Street

In 1996, the London architects Benson & Forsyth won the competition for the design of the Millennium Wing extension to the National Gallery of Ireland and work was completed in 2001. The wing consists of a tall narrow atrium that fronts onto the brick-fronted Georgian streetscape of Clare Street. The dramatic stone elevation to Clare Street has a changing pattern of projecting, recessed and curved masonry panels, sprinkled with a sequence of irregular-sized apertures. At ground level, the square entrance doorway has a tall masonry hood, with multilevel glazing to one side. Internally, the soaring walling is pierced with irregular apertures and stretches from the entrance to the stone stairs that lead to the main gallery. A restaurant opens off one side of the atrium with views of the curved bays of the adjoining Georgian building. There is also a ground-level retail unit on the opposite side, as well as a dramatically placed walkway that cuts diagonally across the atrium at high level.

The vibrant stone sculptural elevation of the Millennium Wing of the National Gallery is set into the brick Georgian streetscape of Clare Street.

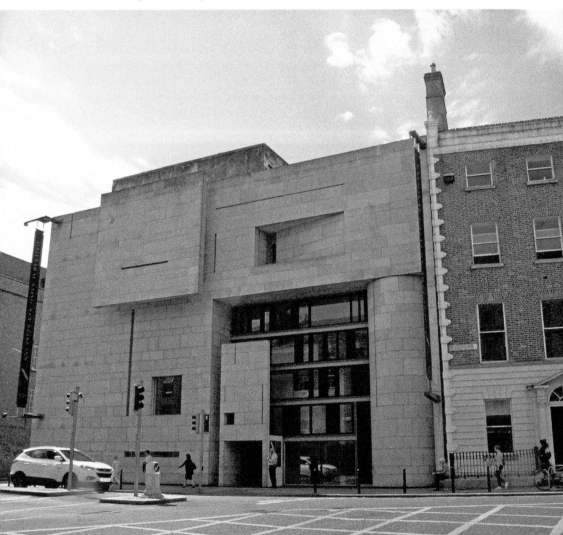

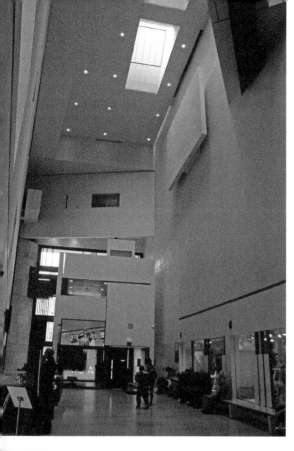

The scale, sheer walling and irregular apertures of the atrium provide an impressive interior to the Millennium Wing of the National Gallery.

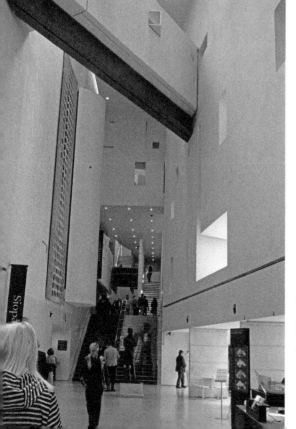

The stone stairway at the end of the Millennium Wing atrium provides a link to the main gallery, with the restaurant to one side and the overhead diagonal passageway.

5c. Bord Gáis Energy Theatre, Grand Canal Quay

The Bord Gáis Energy Theatre on Grand Canal Quay was designed by the American-based international architect Daniel Libeskind. This quayside public building, which is set in Dublin's dockside development sector, offers a visually exciting sculptured composition of interlocking wedged spaces and shapes that overlook the waters of the Grand Canal Dock. Here the elevations of the building visually express the essence of theatrics through the diagonal glass and metal folds that make up the elevations. Internally, the audience is guided to the tiered auditorium in an exciting way by means of intriguing triangular spacers, access ramps, and galleries, as well as steeply inclined steel and concrete structural members. The approach front of the building faces onto an irregular laid-out landscaped plaza that stretches out over the edge of the quay. This was designed by Martha Schwarts and incorporates random low-level seating, coloured paving and a system of tilting uprights that echo the splayed internal and external structural members of the building. The overall result is a remarkable combination of space, structure, landscape, and canal water

The dynamic form of the Bord Gáis Energy Theatre reflects the integration of wedge-shaped forms and structural elements fronting onto the Grand Canal Dock.

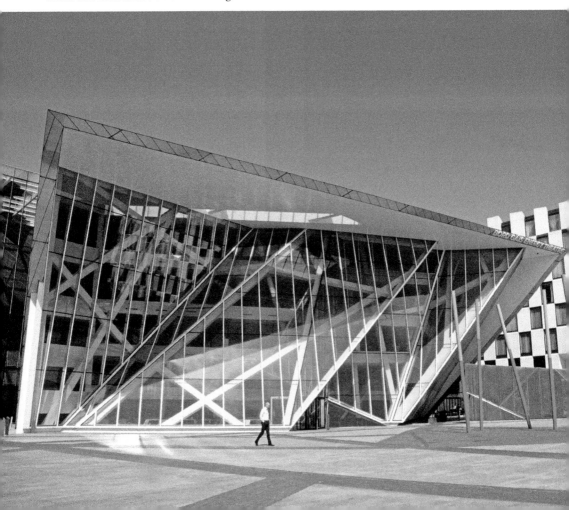

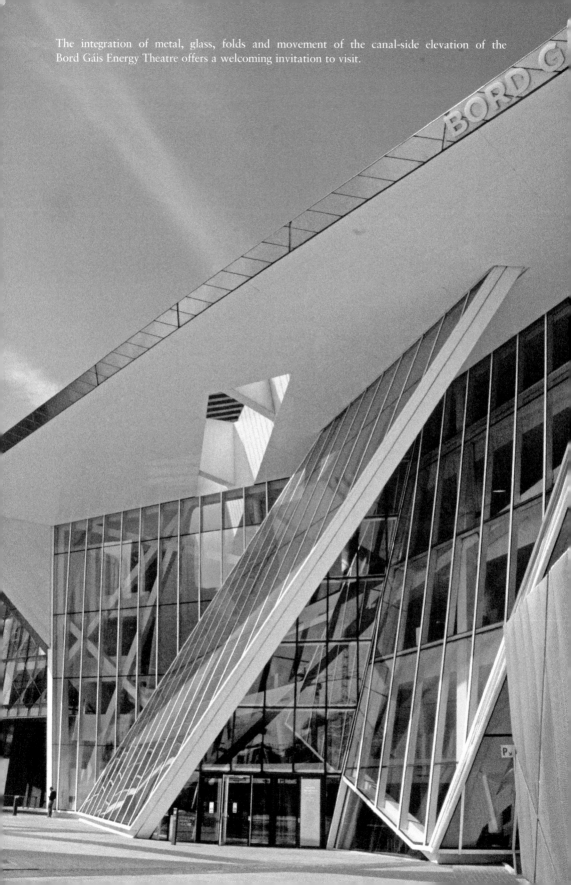

The integration of metal, glass, folds and movement of the canal-side elevation of the Bord Gáis Energy Theatre offers a welcoming invitation to visit.

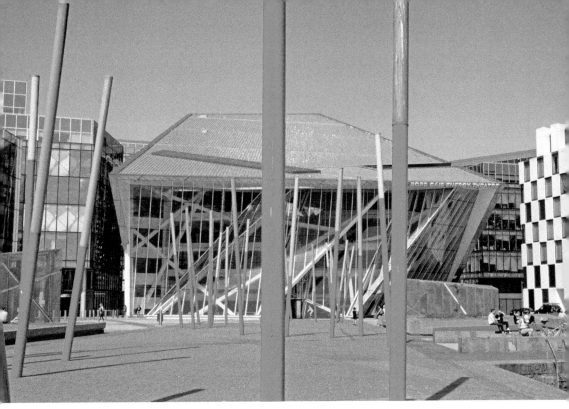

The landscaped approach to the Bord Gáis Energy Theatre with seating, coloured paving and tilting uprights.

About the Author

Pat Dargan is an architect and planner by profession and lectured in physical planning and design. He has a special interest in the heritage and development of towns and villages and he has published and lectured internationally.

Also by Pat Dargan

Exploring Georgian Dublin, 2008
Exploring Ireland's Historic Towns, 2010
Exploring Irish Castles, 2011
Exploring Celtic Ireland, 2011
Exploring Georgian Limerick, 2012
Georgian Bath, 2012
Georgian London: The West End, 2012
The Georgian Town House, 2013
Edinburgh New Town, 2015 (co-authored with Carley, Dalziel and Laird)